the ART of PORTRAIT DRAWING

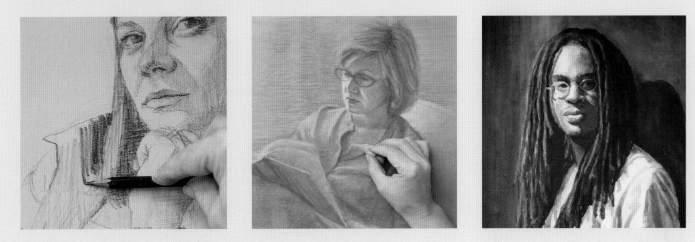

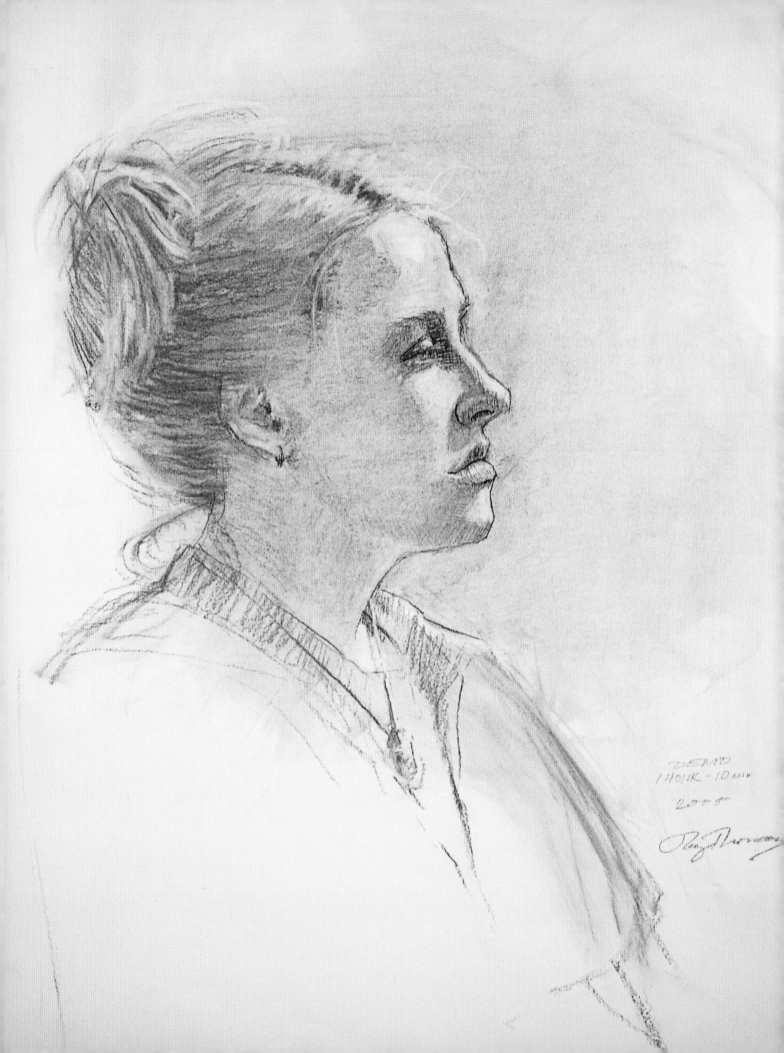

DEMO
1 HOUR - 10 min
2005

the Art of
PORTRAIT DRAWING

Joy Thomas

NORTH LIGHT BOOKS
CINCINNATI, OHIO
www.artistsnetwork.com

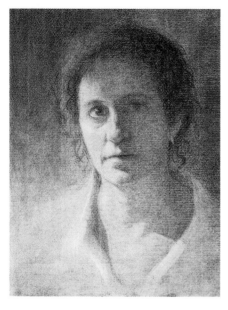

About the Author

Joy Thomas is an extraordinary artist; her beautifully crafted images capture the sitters' features, of course, but also their mood and psychology. Thomas received the first place prize for portrait painting from the American Society of Portrait Artists in 1996. Her work has appeared in *American Artist* (November 1996), *The Artist's Magazine* (April 1997), *International Artist* (January 1999), and in the book *The Best of Portrait Painting* (1998, North Light Books). In the past two decades, her work has been exhibited in museums and galleries all over the United States. Her website is www.portraitartist.com/thomas.

Other fine North Light Books are available from your local bookstore, art supply store or direct from the publisher.

10 09 08 07 06 5 4 3 2 1

DISTRIBUTED IN CANADA BY FRASER DIRECT
100 Armstrong Avenue
Georgetown, ON, Canada L7G 5S4
Tel: (905) 877-4411

DISTRIBUTED IN THE U.K. AND EUROPE BY DAVID & CHARLES
Brunel House, Newton Abbot, Devon, TQ12 4PU, England
Tel: (+44) 1626 323200, Fax: (+44) 1626 323319
Email: mail@davidandcharles.co.uk

DISTRIBUTED IN AUSTRALIA BY CAPRICORN LINK
P.O. Box 704, S. Windsor NSW, 2756 Australia
Tel: (02) 4577-3555

Library of Congress Cataloging in Publication Data
Thomas, Joy
 The art of portrait drawing / Joy Thomas.— 1st ed.
 p. cm
 Includes index.
 ISBN-13: 978-1-58180-712-7
 ISBN-10: 1-58180-712-0
 1. Portrait Drawing—Technique. I. Title.

NC773.T47 2006
743.4'2—dc22 2005033578

Edited by Vanessa Lyman
Designed by Wendy Dunning and Brian Roeth
Production art by Joni DeLuca
Production coordinated by Mark Griffin

Profile in Charcoal (previous page)
Charcoal on bond paper

Chiaroscuro Self-Portrait (this page)
Charcoal on on Fabriano Roma paper

Naptime (opposite page)
Graphite on Arches drawing paper

Metric Conversion Chart

To convert	to	multiply by
Inches	Centimeters	2.54
Centimeters	Inches	0.4
Feet	Centimeters	30.5
Centimeters	Feet	0.03
Yards	Meters	0.9
Meters	Yards	1.1
Sq. Inches	Sq. Centimeters	6.45
Sq. Centimeters	Sq. Inches	0.16
Sq. Feet	Sq. Meters	0.09
Sq. Meters	Sq. Feet	10.8
Sq. Yards	Sq. Meters	0.8
Sq. Meters	Sq. Yards	1.2
Pounds	Kilograms	0.45
Kilograms	Pounds	2.2
Ounces	Grams	28.3
Grams	Ounces	0.035

DEDICATION *For my family*
and in memory of Deane Keller & Jody Boyd

Acknowledgments

With much appreciation to the many artists, past and present, that continue to inspire me… especially my own wonderful students, many of whom are accomplished artists and have become good friends and painting companions.

Many thanks to the patrons, family and friends that have invested in my artwork and Fred's frames; and to my workshop organizers, publishers, editors and brokers for their confidence and enthusiasm. All have helped keep the wolves from the door and food on the table for more than twenty years.

I especially thank the artists who generously passed on their knowledge to me: Burt Silverman, Mary Beth McKenzie, Nancy Guzik, Gregg Kreutz, Deane Keller, Richard Schmid, Pat Jerde, Raymond Kinstler, Sherrie McGraw, Jim Cantrell, Sandy Spiegel, Daniel Greene, David Leffel, Greg Gaby, John Sanden, Carolyn Anderson, Betsy Carmichael, Jeanne Mackenzie, Hollis Williford, Skip Whitcomb, Dan Young, Quang Ho, Jerry Weiss, Ralph Feyl, Dan Gheno… and the list goes on and on.

I want to acknowledge the Lyme Academy College of Fine Arts, the Woodstock School of Art, the Scottsdale Artists' School, The Minnesota River School of Fine Art, the Atelier Studio Program of Fine Art, the Fechin Institute, the Art Students League and the National Academy.

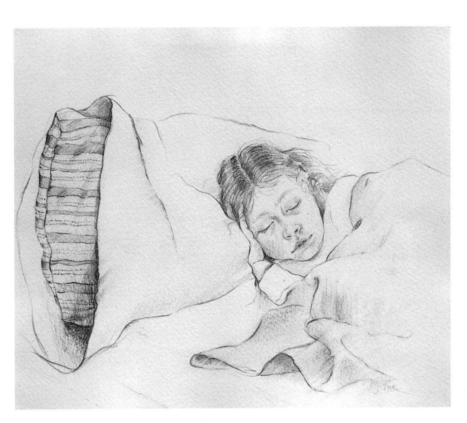

Special thanks to Peggy and Ray Kinstler for their kindness and help with this book. My appreciation to Art Resource, Inc. for their incredible fine art archive and terrific customer service. I could not have completed this book without the dependable expertise of Allied Photocolor in St. Louis.

Last but not least, I am most grateful to my editor, Vanessa Lyman, whose patience, intelligence, humor, hard work and enthusiasm went beyond all of my expectations.

contents

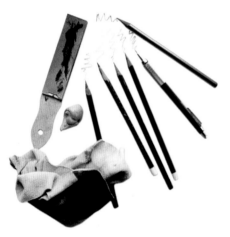

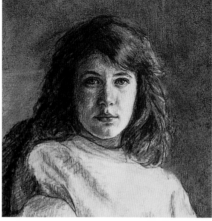

SECTION *one*
Learning the Essentials

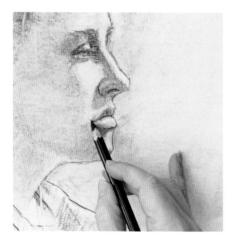

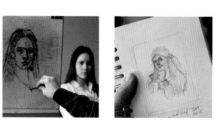

SECTION *two*
Practicing Your Art

introduction

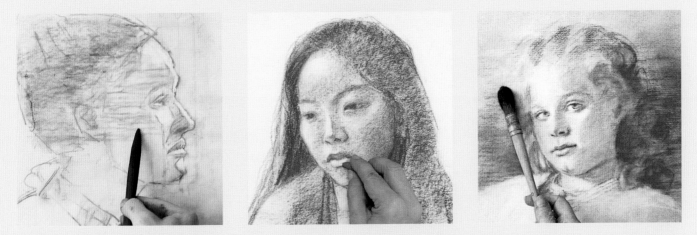

At some point, almost everyone has tried their hand at portrait drawing. First attempts at such a formidable challenge are usually less than convincing, and the entire notion is typically abandoned. For the determined few, the process of capturing a likeness is so fascinating that an intense passion for portrait drawing develops.

With a bit of guidance and a few art supplies, anyone with native talent and determination can develop the skill set necessary to become a fine artist working in the realist tradition. It simply requires continual research, study and practice of the formal elements of art such as line, value, shape, form, space and composition.

This book was written as a primer for anyone, young or old, with a real interest in portrait and figure drawing. It introduces a variety of drawing materials, techniques, methods and styles, and even provides a peek into the history of portraiture with examples of masterpieces from the past. It includes useful information about the human canon, gesture drawing, standard poses, lighting, and working with models. Art teachers and students will appreciate the classic methods of composition and systems of measurement that are explained and illustrated, along with several step-by-step portrait demonstrations.

For most of my life I have been on a quest to become a better artist. It has taken over twenty years to accumulate the basic knowledge that I am sharing in this book. Since I could not possibly include everything there is to know about portraiture, I decided to touch on the information that has proved to be the most life-changing for me.

I wish someone had given me a comprehensive guide like this when I was first attempting to draw portraits. It would have certainly hastened my development and saved me from many years of "re-inventing the wheel."

Go into yourself and test the depths in which your life takes rise; at its source you will find the answer to the question whether you must create, accept it, just as it sounds, without inquiring into it. Perhaps it will turn out that you are called to be an artist.

RAINER MARIA RILKE

Do you remember drawing on blue-lined notebook paper with ballpoint pens and no. 2 pencils? Establishing the darks and the contour lines would deeply indent the pages beneath and those annoying blue lines certainly interfered with the finished drawings. Graduating to typing paper and permanent ink markers was a bit of an improvement but the ink would bleed, sometimes all the way through the paper, staining your parent's furniture.

It's challenging enough to create art without having to fight inadequate materials. Once you've decided to take up the practice of drawing portraits, you'll need to shop for supplies. The good news is that even the best drawing supplies are affordable. Most art supply companies have websites with descriptions and photographs of their inventory, making it is easy to order from the sites with a credit card. Place your name on their mailing lists so you will receive catalogs. If you live near a city, look up local art supply stores in a phone book, take your list and go on a shopping trip. Be sure to ask questions of the clerks; they are often working artists and may offer good advice. If you can't locate what you need, ask the proprietor to order and stock the items for you. When relatives and friends are gift shopping for you, let them know that gift certificates for art supplies would be appreciated.

Charcoal

In many drawing classes, this is the first medium you use. Charcoal comes in a variety of densities and sizes. Vine or willow charcoal is available in varieties thin to thick, extra soft to hard, and may be purchased in boxed assortments. Both are made by burning actual sticks or twigs in a kiln. This charcoal is very fragile and breaks easily. Willow is the best choice, as it has the finest particles and the best consistency. It's used in preliminary work and is easily manipulated or removed, so it must be sprayed with a fixative before transporting or framing.

Compressed charcoal is made by mixing charcoal powder with a gum binder, which is then compressed. It comes in densities from extra soft to hard, in shapes round and square. It imparts a velvety, dark mark that is useful for making broad stokes, finishing work and creating large portraits.

Wooden charcoal pencils, especially useful for linear and detail work, are made from compressed charcoal and range from extra soft to hard. Charcoal, an impure form of carbon, also comes in powdered form.

Chalks, Crayons and Pastels

Wooden chalk pencils and Conté crayons come in many hues including the traditional colors of sanguine, sepia or bistre, white, gray and black often

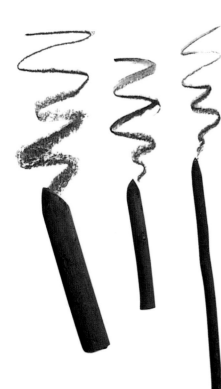

Charcoal
From left to right, the charcoal supplies include three variously sized sticks of compressed charcoal, vine charcoal, a charcoal pencil and willow charcoal.

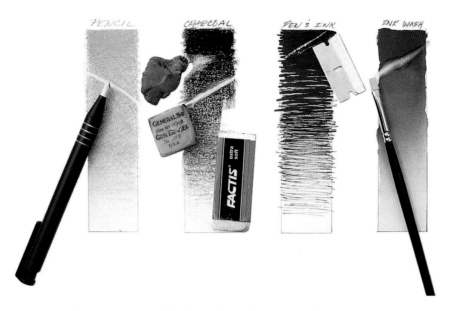

seen in portraiture. Unlike charcoal, chalks and pastels along with graphite pencils contain binders. When graphite was in short supply during the Napoleonic Wars, Nicolas-Jacques Conté created a crayon that is still known by his name. Today's Conté crayons are actually a variety of chalk. The traditional Conté colors are sepia, sanguine, white and black.

Pastels are made with pure pigment and are noted for their brilliant hue and value range. A pastel sketch leaves much of the ground exposed and the pastel marks may appear grainy and sketchy. When the support is covered with many layers of pigment, it's called a pastel painting rather than a drawing.

Subtractive Tools

Subtractive drawing might seem like a fancy term for erasing, but it's actually about lifting tone to shape form, add line or create highlights.

Retractable erasers are refillable and can be sharpened to a point. This works well for edges, lines, highlights and details.

Kneaded erasers are incredibly useful for erasing, lifting and redistributing tone. Since they can be stretched and shaped, kneaded erasers are excellent for subtractive work. Extra-soft erasers are great for lifting and cleaning large areas of charcoal without

Subtractive Tools
The tools above include a retractable eraser, kneaded eraser, gum eraser, extra-soft eraser, single-edged razor blade and bristle brush.

abrading the paper. Single-edged razor blades can scratch through ink.

Tortillions, Stumps and Chamois Cloth

Tortillions are made of rolled paper felt and are pointed on one end. Blending stumps, which are pointed on both ends, are also made of paper felt but can be sharpened or sanded for details and softening techniques. These tools are excellent for toning.

Authentic chamois cloth (available at auto supply stores) is useful for toning and subtractive work.

Chalks, Crayons and Stumps
Featured here are three chalk pencils (black, sanguine and white), a kneaded eraser, Conté crayons, a tortillion and two blending stumps.

Graphite Pencils

Graphite has been around for centuries and was first used by the Aztecs. The word "graphite" is derived from the Greek *graphein,* which means "to write." Europeans discovered it in the 1400s, but the substance wasn't named graphite until the late 1700s. Today's graphite pencils are made from a paste mixture of graphite, clay and water which is then fired. Varying the amount of clay in the pencil determines the hardness. Harder pencils contain more clay. Graphite also comes in a powdered form.

Graphite pencils are available in different grades of hardness, from 10H (the hardest) to 8B (the softest). The higher numbered the H, the harder the pencil. The the higher numbered the B, the softer the pencil. The two other grades are HB and F, which are in-between grades. These are useful in the preliminary stages of a drawing. I've noticed that artists typically prefer the softer, darker pencils. A common selection of graphite pencils used for portrait drawing might include F, 2B, 4B and 6B.

Another form of graphite is the woodless graphite stick. These are made of a length of graphite sealed with a resin coating. Compressed graphite sticks without the resin coating are also available.

There are many sizes of mechanical pencils. Most are self-feeding and can hold several leads in the barrel. Other holders are available for use with individual leads, charcoals or chalks.

Pencil sharpeners are certainly available, but many artists sharpen their tools with a knife and use sandpaper pointers to adjust the point of their pencil or charcoal. Sandpaper pointers consist of sheets of sandpaper on a paddle.

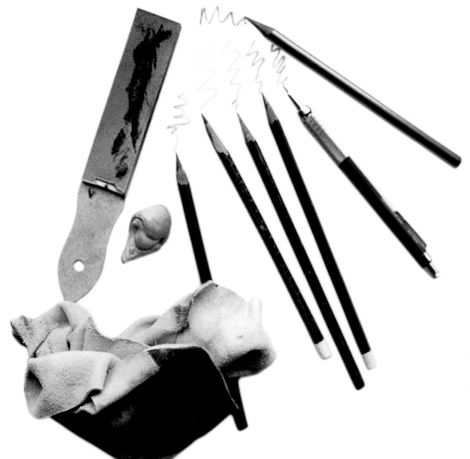

Graphite Pencils, Pointers and Chamois
Shown are a sandpaper sharpener, a kneaded eraser, a chamois cloth, four graphite pencils of varying hardness, a mechanical pencil and a woodless graphite pencil.

Ink

The Old Masters were limited in their choice of inks. Today there are many lightfast inks available in a whole spectrum of colors, along with a plethora of superb artist's pens and markers in an array of sizes with points ranging from fine to ultrafine. Traditional favorite inks include the transparent and luminous brown-bistre and sepia. Quills, fountain pens and brushes may be used with bottled inks.

Ink drawings vary according to the tools and techniques used. Many resemble plate etchings, while others appear as wash paintings with linear accents. Look to Masters like the eighteenth century Giovanni Battista Tiepolo for magnificent ink drawings.

Sumi ink sticks are made of permanent ink from soot. These dry sticks are used with traditional grinding stones and water to produce inks of various intensities for use with brushes. Sumi ink sticks are often attractively gift boxed with water pans, stones and brushes. The large professional stick is typically of better quality and produces nice results when used with squirrel-pointed round brushes and wirebound quill wash brushes.

Pen and Ink Tools

The tools featured here include five markers of varying thickness, two ink wash brushes, a bottle of India ink, a box of dry Sumi ink sticks and a grinding tool called a Suzuri stone.

Silverpoint

Silverpoint, the ancient ancestor of the graphite pencil, consists of a sharpened silver wire held by a stylus. Silverpoint requires a very smooth surface; it can be used with various papers, but is usually applied over a prepared ground containing lead white, silica or marble. The marks are gray at first, then tarnish to a warm, mellow tone of subtle contrast. Silverpoint is known for its precise hatch mark and its luminosity. Other metalpoints such as gold and copper may also be used.

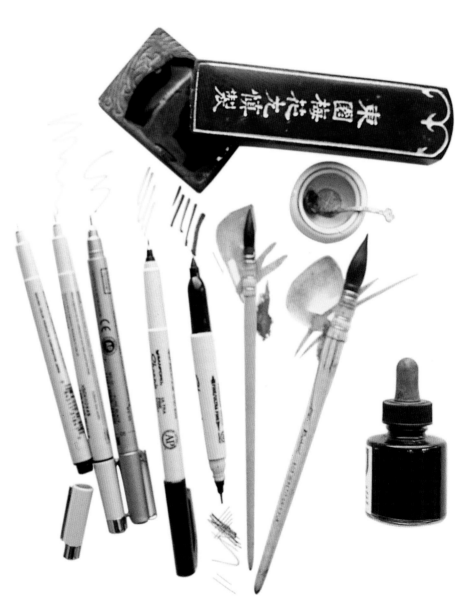

The possibilities for using your drawing materials are, of course, limitless, but there are traditional methods of application.

Hatching is a drawing or painting technique in which one draws close parallel lines to build tone and shadow. The appearance of the single hatch will vary according to point and medium.

Cross-hatching is the application of single hatch marks over existing ones, in a different direction, to darken the tone.

Side strokes are accomplished by drawing with the side of a pencil point or crayon to achieve a wide mark or tone. The appearance will vary according to the surface texture of the support.

Broad strokes are made with the use of a chisel point or the edge of a broad tool like a stick of charcoal.

Blending can be an effective way to achieve broad areas of tone or value. The "rubbed line" is a technique that has been used for centuries to manipulate or attend to an edge. Blending can destroy the integrity of a drawing, so it's important to avoid overusing this technique.

There are many other techniques, including stippling (applying dots), splattering, dusting and line variations such as broken, graded and accented line. Look for these techniques as you study the work of others, and try it out in your own.

Mixing Wet and Dry Media

Betsy is my partner in crime when it comes to plein air painting. We have traversed the country painting like mad along the way, from the mountains of Montana and Appalachia to the streets of Manhattan to the bucolic fields of Kentucky and Indiana. An art instructor and close family friend, Betsy is a source of inspiration and encouragement to all that know her.

For this portrait, I used a wash of one part white gouache to two parts Raw Sienna watercolor to tone Strathmore 400 Series bristol board. After it was thoroughly dry, I wet the highlighted areas and then lifted the paint with water and a stiff brush, blotting with a paper towel. Then I drew on the dry paper with Conté crayons in black and sanguine, working primarily in horizontal hatching, for this unique look.

Betsy (opposite page)
Watercolor and Conté on bristol board

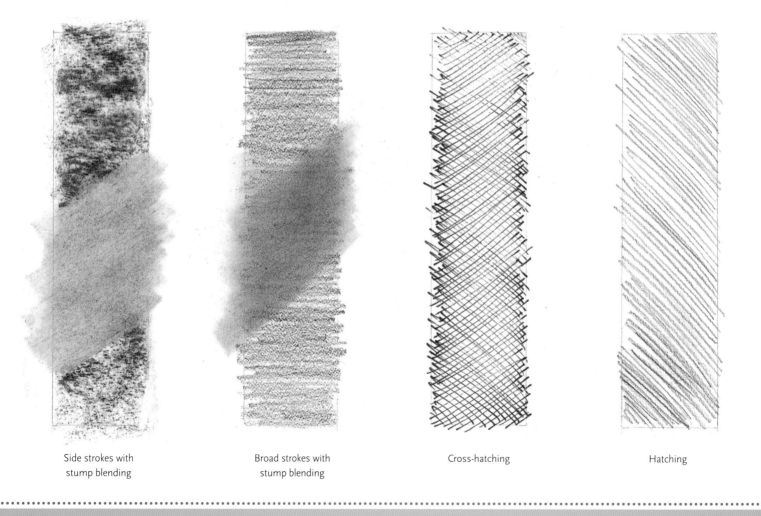

| Side strokes with stump blending | Broad strokes with stump blending | Cross-hatching | Hatching |

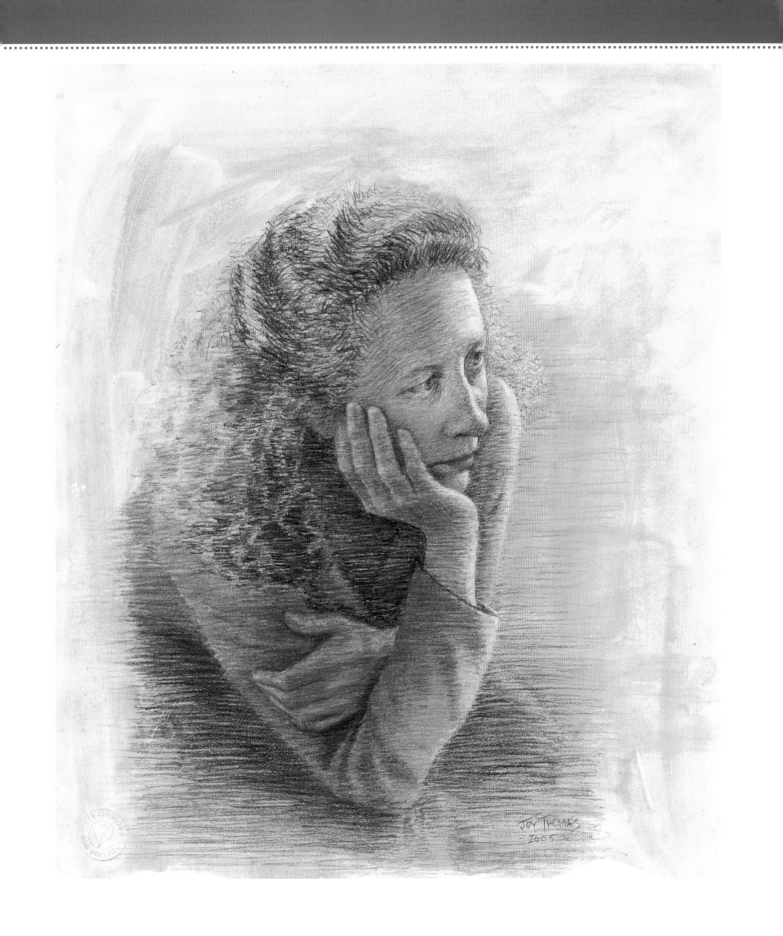

Paper is as important to your artwork as the charcoals and pencils you make your marks with. A good paper can make or break a drawing. It can make the drawing process easier or more difficult. The archival quality can also affect the durability and actual value of the work.

For large-scale practice, most artists often use large pads of newsprint paper, but investing in more permanent paper, like bond paper, can definitely be worthwhile. Papermaking is an art in itself. The finest drawing papers are amazing to behold and can have a true bearing on the aesthetic success of one's efforts. From plate bristol to handmade, drawing papers come in a plethora of grades, textures and colors.

Types of Papers

Bristol is a durable, all-purpose white paper that accepts all drawing media, including washes. The plate finish is a hard, smooth nonabsorbent surface, while the vellum finish has a bit more tooth and is slightly absorbent. Both have strong surfaces that can stand up to repeated lifting and erasure. Good bristol is made from 100-percent cotton rag (see sidebar) and its thickness is determined by the ply, with two- and three-ply being the most common weights for drawing, while four- and five-ply are lightweight boards.

Bond papers have a finish similar to bristol and work well with most drawing media. Ledger bond has a plate surface and is opaque, while layout bond has a texture more like vellum and is lightweight and somewhat translucent.

Vellum is transparent and features a smooth surface suitable for line drawing media including pencil and pen. It has a durable surface that resists repeated erasure.

Clay coat has an ultra smooth, min- eral-coated surface. Its slightly absorbent finish is designed for use with pencil, inks, silverpoint and multimedia.

Some printmaking papers have smooth, flawless surfaces that are slightly mottled to resemble vellum. Their deckled edges and subtle hues are aesthetically inviting and offer a nice surface for pencil, charcoal and Conté crayons.

Charcoal papers have more textured surfaces and come in many colors and finishes. A woven or laid paper has the screen imprint of the maker's mould, while an irregular finish is the result of the felt mats used while pressing out the wet sheet. The handmade papers are exquisite in hue and texture.

Sumi paper is an acid-free, white rice paper used for drawing, pen and ink and Sumi ink work.

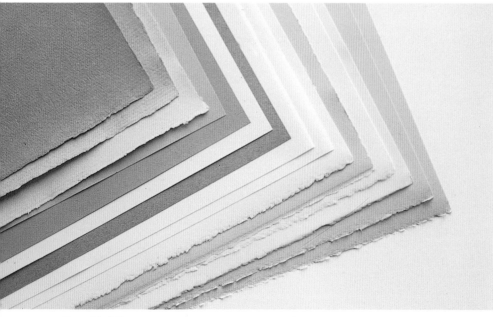

Paper Varieties
Paper comes in a wide variety of colors, textures and edges. Treat yourself to a new paper on occasion and experiment. You may just find your favorite new paper.

ACIDITY

Factors such as fiber content, sizing, the water, and the chemicals used during production and storage determine a paper's acidity and permanence. Generally, you will want to choose a paper that will withstand the test of time.

"100-percent rag" means the paper is neutral pH, permanent and the fiber content of the paper is of non-wood origin, including actual cotton. Some sulfite or wood pulp papers are also neutral pH and considered permanent. Buffered paper is considered permanent. Even a paper that is not buffered can last a long time if properly stored.

Sketchbooks

Purchase artist's sketchbooks and notebooks in a variety of sizes. It's best to select those of archival quality with spiral or stitched bindings. Office and school supply stores carry a selection of binders and other storage packs that have pencil pockets and will hold a 5" × 9" (13cm × 23cm) or smaller sketchbook, erasers and a selection of drawing pens and pencils. This makes a wonderful studio-to-go. Carry the pack with you so you can sketch in airports or on buses, and to take notes while drawing from your favorite works in museums.

Keep larger sketchbooks and your favorite drawing supplies handy at home. Shop for small, plastic storage boxes with dividers in the fishing or tool section of your local department store; some of these make perfect pencil cases.

Whether you're at home or on the go, you'll be more likely to draw if your materials are organized and within easy reach.

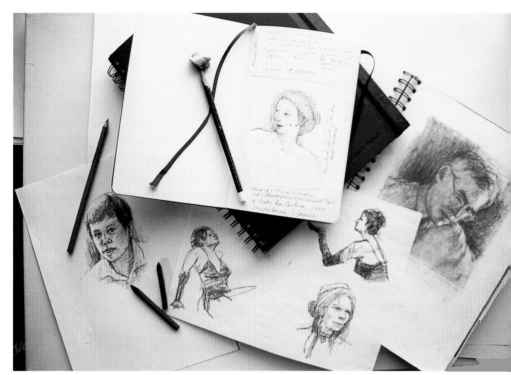

Sketchbooks
Keep a sketchbook with you and draw as often as you can.

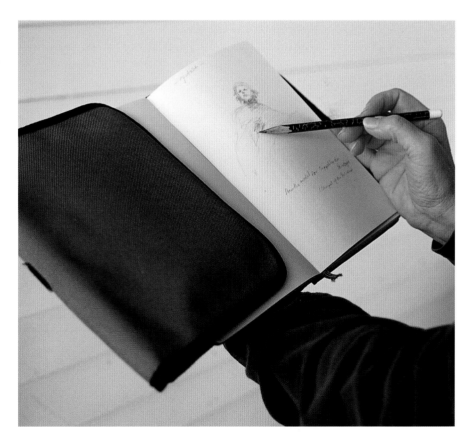

A Drawing "Travel Pack"
This binder holds a sketchbook and has a pocket on the inside flap that can hold erasers, a pencil sharpener and a variety of graphite and charcoal pencils and drawing pens. It's a convenient way to keep drawing supplies with you.

When our youngest son was just two years old, he crawled over a baby gate onto the enclosed porch that I was using as a makeshift studio. I had stepped out for a bathroom break, so he made his way to the palette, loaded the largest brush he could find with Cadmium Red and proceeded to "help Mama paint." He added some final touches to the large commissioned portrait that I, proud and pleased, had signed just a moment before. You can imagine my response when I returned to the grisly scene! My anguished cries brought the rest of the family running. My husband whisked the culprit upstairs to safety as I crumpled to the floor in tears.

"It's time for a real studio," I announced at the dinner table as we gathered for our next meal.

If we had it to do over again, we would build something much larger than this 20' × 20' (6m × 6m) building. The studio gets a bit crowded when I share it with my husband, who makes museum-quality frames. He uses other outbuildings on our property for the major woodworking but comes into the studio for delicate carving, gold leafing and patina work. We also share an office in the house, with a computer, printer and fax machine. The studio is just a few steps from the house, and was great when we had little children, but now I wish my house, office and studio were connected.

My dream studio would be at least 40' (12m) long on the north side, with proper artist's skylights at the perfect angle, a station for each medium (oil, pastel, watercolor and drawing), a large storage room for furniture and more props, an efficiency kitchen, a bathroom, gallery space and an office. I would also like to have space to teach classes and host workshops. I've traveled around looking at old schools, churches, banks and lofts with the intent of finding a location to house all of the above. Who knows? Maybe it will all come together someday. In the meantime, I'll just continue working in my nice, modest studio.

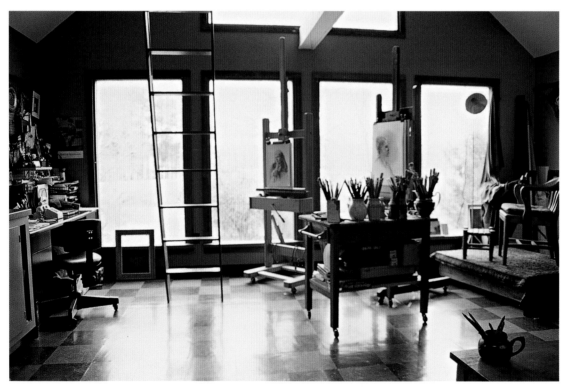

North Light
I wanted a studio with lots of north light, separate from the house. We salvaged five large windows, discarded by the local hospital during an expansion project. The fixed windows are commercial grade, double-glazed and sealed in stainless steel. They were built into the gable end of the north wall of the studio.

We left a wide opening in the ceiling along the north wall to take full advantage of the light and to serve as the open end of the storage loft. The ladder to the loft is mounted on a track so it can be moved from side to side.

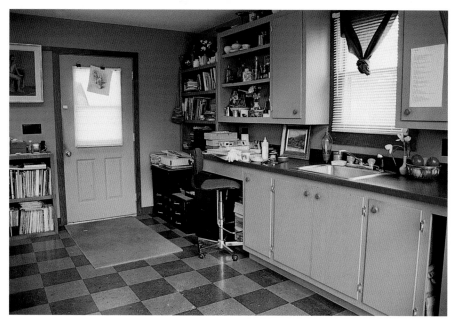

Storage Space

Every good studio needs a lot of storage space. I traded artwork to a carpenter friend for the cabinets, countertops and bookshelves in mine. The lower cabinets conceal pullout drawers for storage and files. Drawing papers are stored in metal map drawers. The small window and the stainless steel sink were additional bargains from a salvage yard.

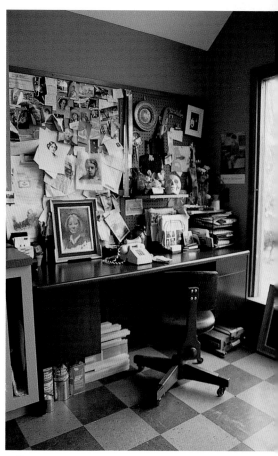

Office Space

The combination cork/peg board is covered with information, inspiration and frequently used tools. The telephone and Rolodex are at this desk, another salvage-store find; I use its two file drawers for my most current jobs.

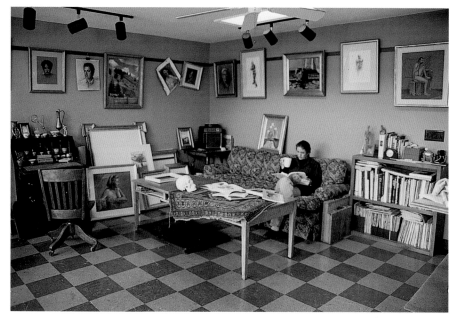

Sitting Area

I splurged on a tapestry-covered sofa for the seating area, which provides a cozy spot for reading art books or drinking a cup of tea. The large, oak school table was purchased at auction and doubles as workspace for gilding frames and a coffee table. It also has cubbies on both sides for additional storage space. A picture rail saves the walls from nail holes. The inexpensive track lighting can be adjusted to illuminate the artwork on the walls. The antique English desk, where I write letters and sort papers, was received as partial payment for a portrait I did a few years ago.

Drawing From Life

A traditional exercise for the portrait artist is the head study from life. Artists typically approach this challenge with solemnity and reverence, and rightly so. The ability to execute a convincing portrait from life in just one sitting is the standard by which the true abilities of a portrait artist are measured. It reveals one's training and knowledge, and serves as the ultimate reward for years of hard work.

Those who work only from photographs are missing out on something grand. Nothing quite compares to the intellectually challenging and emotionally stimulating experience of drawing, painting or sculpting portraits from life.

Working With Models
There are a number of ways to work with a live model. Typically, your first models will be friends and family. This may prove frustrating when they realize how physically tedious modeling can be and begin to fidget or move about. Try to be patient, while bestowing lots of compliments, good food, extra breaks and artwork in return for their cooperation.

You can hire an artist's model by posting an inquiry through the art department of a university or art guild. Theaters might be a good resource for subjects because actors are usually comfortable with the idea of modeling.

Professional artist's models typically charge ten to twenty dollars per hour, depending on their experience and the location. Some models may charge for travel time or require mileage compensation. Expect professional models to have their own "mode of operation" when it comes to length of poses, hours of availability, costuming and so on.

On occasion, you may spot someone so interesting that you are compelled to ask them to pose for you. Of course, you should be cautious about approaching strangers and know that you might frighten the subject. Introduce yourself by offering a business card and examples of your work through photos, brochures, portfolios or a website. Play it safe by approaching those who are somewhat familiar with you that see you from time to time, such as clerks, mechanics, tellers, ushers and receptionists. You should only work with minors with the permission of the parents, and even then, always request the presence of a guardian at the sitting.

Portrait Commissions
As you gain experience and your reputation grows, clients will come to you with portrait commissions. Make a policy of requesting sittings from life, even when the client expects you to finish the commission from photographs. Always take your own photographs. Unless the subject is deceased, don't agree to work solely from someone else's photographs.

Once you have scheduled a sitting with your subject, get organized. When traveling to the subject's location make sure to pack a pencil case loaded with charcoal, Conté crayons, pens, pencils, chamois cloth, kneaded erasers and tortillions. Also pack a drawing board, padding, papers, viewfinder, Bulldog clamps, supersized rubber bands and fixative. Bring your camera if you intend to work from photos. If you don't intend to use photos, leave the camera behind. The drawing-from-life experience will be much better if you can manage to keep the process camera-free.

Sessions in Your Studio
If the model is coming to your studio, tidy up a space just for them. It is preferable to elevate the subject on a model stand so that you are eye to eye if the model is sitting. You can make a model stand with a sheet of sturdy plywood and five concrete blocks (one on each corner and one in the middle), or you can hire a carpenter to build a model stand. My studio is equipped with a wooden chest on casters that serves as a combination model stand/storage unit for costumes, drapes and other props.

Consider placing a mirror so your subject can watch the portrait in progress. A wheeled, full-length mirror is ideal. This keeps the model engaged and alert while intensifying the bond between artist and model. Provide cushioned seating, a timer and water. Make your subject feel at home by offering refreshments and ensuring their comfort. Provide a sound system and invite the model to select the music for the sittings.

Have your paper secured to the drawing board and your drawing tools arranged and ready for use beforehand. Be prepared to set the pose and begin drawing soon after the model arrives.

TIMES HAVE CHANGED
The French Academy, established in 1648, required its students to spend years drawing from prints and plaster casts of classical sculpture. Students were required to exhibit mastery of anatomy, contour, light and shade before being granted permission to draw from a live model.

Seeking Out Your Subjects

Of course, it's ideal to work with professional models in a studio setting, but it's also stimulating to draw in cafes, on the street, at festivals, in airports, at bus stops, in the library, at the park and any other place where people are gathered.

As the saying goes, "Practice makes perfect," so it's important to make a habit of drawing from life regardless of the setting.

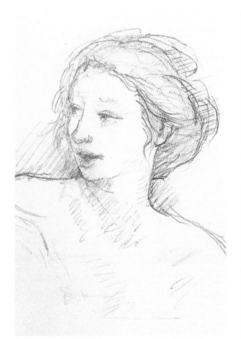

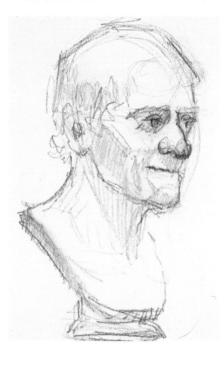

A Treasure Trove of Subjects

Museums make excellent places to sketch. Fill sketchbooks with studies of your favorite paintings, etchings and sculptures. Be sure to include notes about the artist, medium, museum and the date. If you tire of drawing museum masterpieces, you can always sketch the other visitors.

Working from life develops more than just drawing skills. It creates an intimacy with and a knowledge of the model that is impossible to achieve from working from photographs alone. Even if you plan to complete the portrait from photos, you should attempt a study or two from life before beginning the final piece. The result will be much improved for your efforts.

My mother-in-law has seven children and lots of grandchildren. Everyone in the family calls her Grandmother. She and my late father-in-law raised their family on their small Kentucky farm, where she cooked with fresh vegetables from her garden and enjoyed setting lovely tables for family gatherings. She made many beautiful quilts, enjoyed her perennials and was kindhearted to a fault.

A stroke seven years ago left her a bit debilitated, so she moved into an assisted living facility in a neighboring town.

At eighty-nine, she is still bright and friendly, and simply loves visitors, so I try to visit her every week or so. On a recent visit, I decided to bring along my sketching backpack. Grandmother seemed especially pleased when I asked to draw her portrait.

It soon became apparent that she didn't have the attention span to hold a pose longer than a minute or two. She was also determined to keep a conversation going, inquiring about the children, sharing personal observations and reminiscing. She even nodded off to sleep at times.

I had to slow my pace, watching for her to strike a pose every now and then. She kept turning her head, to first look at me, then out of the window, so I abandoned the first drawing and repositioned myself so she could look at both with less movement.

We took lots of breaks so she could see the drawing. She was delightfully bemused. At one point, she wondered aloud "where artists come from" and why some people seem "talented that way."

As day slipped into evening, I finished my little pencil study and took a few photos before heading home. The photos echo the same pose as the sketches, along with skin tones and background information. Armed with so much reference material, I'm looking forward to painting a finished portrait sometime.

Working from life is important, if not to develop drawing skills, to develop one's character. Frequently, both the artist and subject feel like they've connected to one another on some level, and they treasure the experience as a decidedly humanistic moment in their lives. It's worth it.

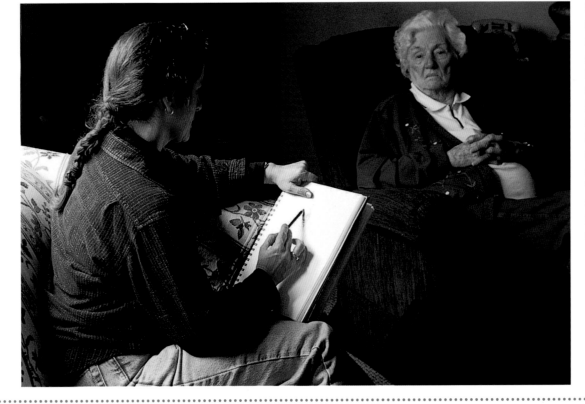

Drawing Grandmother
Grandmother seemed especially pleased that I wanted to draw her. She had a hard time holding a pose for a long period. Her need to shift encouraged me to slow down and observe carefully. Waiting for her to strike a pose forced me to be patient and attentive.

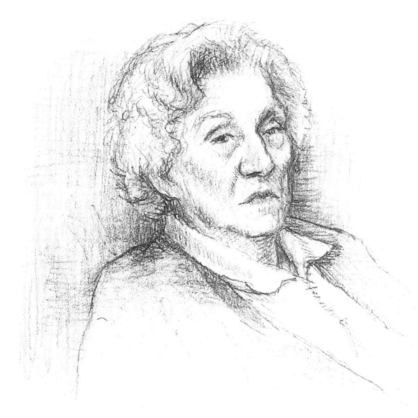

One of the Resulting Studies

I realize this piece is not a show-stopper, but I'm amazed I got anything out of the day. I snapped a few photos of Grandmother. Combined with the series of drawings and little studies I did throughout the day, I should be able to paint a finished portrait later on. The initial drawings will mean as much to me as the future portrait; they unfolded as she watched.

Grandmother
Graphite on bond paper

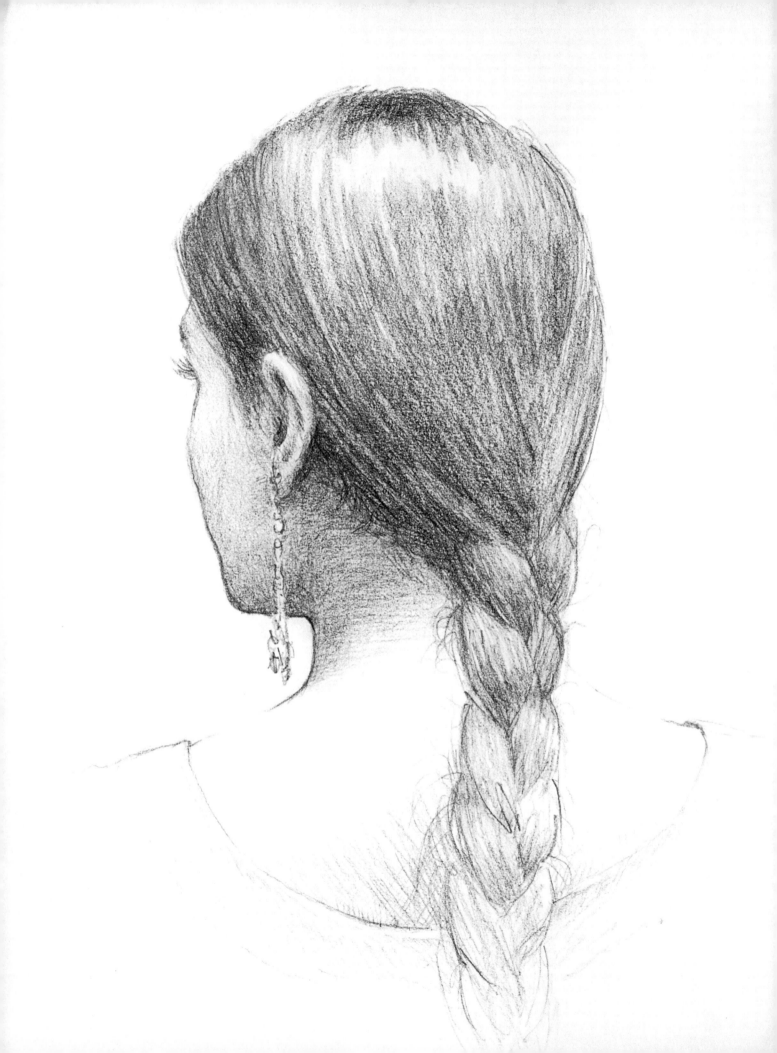

Learning the Essentials

Today, artists have complete freedom to create as they please. There are no strict requirements for membership into current portrait societies, guilds or registries. In fact, only a few select academies still teach rigorous courses in figure drawing.

For some three hundred years, until 1968, competitors of the French Academy's *Prix de Rome* were sequestered in studios for seventy-two days to produce their final competition pieces, then the winners were awarded generous stipends and fellowships to study at the Villa Medici in Rome for up to five years. To win this coveted prize, an artist's skills of portraiture had to be honed to a masterful degree.

I'm not recommending a return to the ways of the French Academy, but I do think there should be more emphasis on teaching—and learning—how to draw. During the past few years, I've seen a growing demand for instruction and information about traditional drawing. Artists demonstrating an ability to work from life are still respected by their peers and are sought out by collectors.

For years, I begged, borrowed and saved to study with the best, and then worked tirelessly to become the best portrait artist I could be. While I can't teach you everything you need to know in these few pages, here are the essentials for becoming an artist.

Lost Profile
Graphite on bond paper

DRAWING THROUGH HISTORY

Throughout history, there has been an interest in drawing, and as long as people have been drawing, there have been attempts to depict the human form. From the earliest images on cave walls to the most recent avant-garde exhibitions, we find the portrait.

We can learn from existing works of art by studying, absorbing and implementing their lessons. It is inspiring and informative to look at portraits by other artists, both past and present. Since the style and technique used in creating a portrait often reveals more about the artist than the subject, it is important to be aware of why, and how, we draw.

Representational portraits can be placed in various categories, including symbolic, stylized, idealized and naturalistic. Learning to recognize these approaches will help you in choosing and building your own means of expression. The differences between these are obvious in some cases, while quite subtle—or even overlapping—in others. It all depends on the circumstances, abilities and the intent of the artist. It is helpful to know something about the circumstances in which particular works were created. During certain periods in history, artists were held to rigid standards by the guilds of their day, and the content of their work was strictly controlled. Even today, most artist are heavily influenced by educational and cultural trends or by the demands of buyers. Once you are able to identify and recognize the differences between certain styles and periods, you will be better equipped to achieve the look you want with your own portraits.

In the next few pages, you'll see inspirational portraits that are somewhat naturalistic regardless of the age in which the artist worked or the techniques used. In each case, the intent of the artist is clear: to capture the presence and mood of the subject while conveying some sense of reality.

Symbolic

Symbolic drawing often indicates that an untrained or provincial hand did the work. Symbolic drawings are hieroglyphic in nature and often appear in tribal works, antiquities or in drawings by children and lay people. Some contemporary works were created by exploiting symbolic drawing in a conceptual, affected way. That type of symbolic drawing evolves into a stylized approach. Many artists of the Twentieth century, such as Picasso, Matisse, and Modigliani, became famous for developing symbolism into an intentional style. Because symbolism is our first visual language, it can be very appealing to viewers. For the artist attempting to create realistic portraits, the natural urge to use symbolism is difficult to overcome.

Stylized

Stylized drawing can be found among many works through the ages. Egyptian and Roman portraits were often stylized, as were many Asian works.

The Golden Age of Illustration of the late nineteenth and early twentieth centuries saw a proliferation of trained illustrators creating charming, stylized etchings and drawings. Look through old children's books for good examples by Arthur Rackham, N.C. Wyeth, Elizabeth Shippen Green, Howard Pyle, Alphonse Mucha, Aubrey Beardsly, Grace Gilkison and many more. Regionalists such as Thomas Hart Benton and Grant Wood were known for their stylized portraits. Newspapers and magazines often feature highly stylized figure works created by graphic artists and cartoonists. Contemporary illustrators continue the tradition and, once again, children's books are good venues to see examples.

Idealized

Michelangelo, Raphael, Rubens and Rembrandt were Renaissance artists. Art academies of the Renaissance provided students a high level of technical ability through rigorous training that emphasized drawing, taught specific systems of measurement and required a disciplined study of anatomy. Academic artists were also taught, and sometimes required, to idealize portraits and figures based on particular canons.

The French Academy established an actual hierarchy for art such as classical, religious, mythological, allegorical and other idealized narratives, which were considered more important than scenes taken from everyday life.

The work of Jean Auguste Dominique Ingres, Adolphe William Bouguereau and Charles Bargue epitomize Academic art. Other art movements that embraced idealism include Neoclassicism, Romanticism and the Pre-Raphaelite movement.

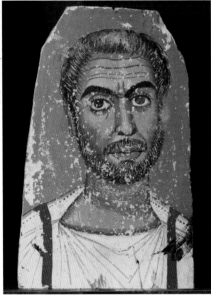

SCALA/ART RESOURCE, NY

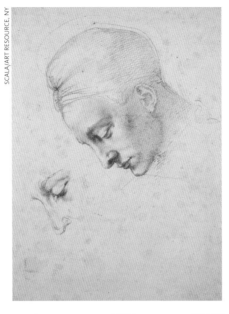

Capturing Mood

Even though this drawing by Michelangelo is somewhat idealized in keeping with the conventions of the day, it is beautifully conceived and expresses an immediate mood, compelling the viewer to empathize with what appears to be a real personality. The virtuosity of the draftsman is evident in this masterpiece. This particular study actually sparked my own fascination with profiles.

Study for the Head of Leda
Michelangelo Buonarroti (1475-1564)
Gabinetto dei Disegni e delle Stampe
Uffizi
Florence, Italy

An Early Portrait

This ancient portrait is a good example of the overlapping of styles. While it certainly has symbolic and stylized aspects common to the genre, this portrait is exceptionally realistic for the period. It seems that the artist was attempting to depict the subject in a more naturalistic way than other funeral portraits from the period. Limited resources and abilities may have hampered the artist's intent, but the intent is still there. This portrait provides an intriguing glimpse into the past.

Bearded Man, funeral portrait
Tempera on wood
c. 4th CE, from Fayum, Egypt
Kunsthistorisches Museum
Vienna, Austria

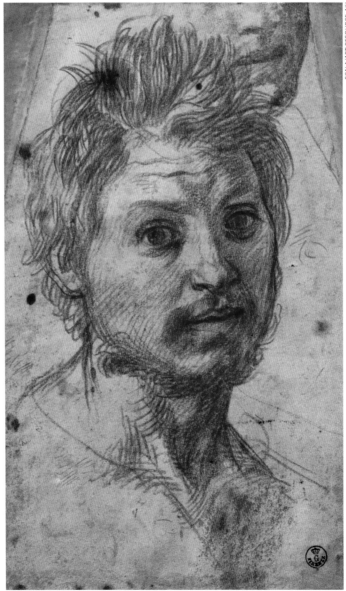

SCALA/ART RESOURCE, NY

An Energetic Drawing

According to the writings of Giorgio Vasari, Andrea del Sarto could draw "perfectly." This artist has been the called last great classical painter in Florence before the birth of Mannerism. The bold strokes of this study are representative of his masterful and energetic drawing style. Even though he was trained in the aspects of idealism, he chose a naturalistic approach with this study. The extensive value range, along with the intense expression of the model, add power to this haunting portrait.

Study of a Male Head
Andrea del Sarto (1486-1530)
Red chalk drawing
Gabinetto dei Disegni e delle Stampe
Uffizi
Florence, Italy

Naturalistic

Through the ages, artists have made attempts to depict the figure in a natural and honest way. The Greeks certainly took pride in their knowledge of anatomy, and we see naturalistic work from other eras. Around 1600, the Baroque period ushered in a heightened interest in naturalist work. In the 19th century, artists of the Realist movement used the skills they had acquired through formal academy training to depict their subjects in a naturalistic manner, without excessive idealizing. They favored the ordinary canon rejecting the use of the heroic or ideal canon as unrealistic. (We'll earn more about these canons on page 36.) The Realist movement became full-fledged by the mid-nineteenth century and led to the creation of many works by Impressionists and the Naturalists featuring ordinary people in everyday settings. Artists from this period include Anders Zorn, Joaquin Sorolla, John Singer Sargent, Thomas Eakins, Valentin Serov, Frank Duveneck and Cecilia Beaux, among others.

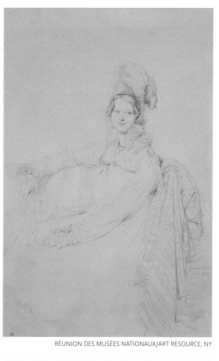

RÉUNION DES MUSÉES NATIONAUX/ART RESOURCE, NY

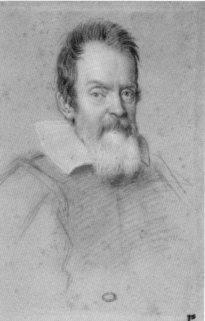

SCALA/ART RESOURCE, NY

A Masterful Line Drawing

Ingres was a master of line drawing. His portrait drawings are noted for their skillful and expressive use of contour. Wealthy and fashionable patrons admired the idealized portraits he created for them. This drawing typifies his style and his sensual approach to line that transcended function. The finished face creates focus, while the peripheral parts remain loose and calligraphic, inviting the viewer to "finish" the rest of the figure. Ingres' drawings are almost magical in their simplicity and attest to the artist's innate ability to employ gestalt thinking, a theory we'll discuss on page 30.

Portrait of Mme Louise-Nicolas-Marie Destouches
Jean Auguste Dominique Ingres (1780-1867)
Graphite drawing
Réunion des Musées Nationaux

A Convincing Likeness

This drawing is a direct and naturalistic portrait of someone quite famous: mathematician and scientist Galileo Galilei. This Baroque artist allows us to look upon the man as he was at that moment, receding hairline and all, and we believe the depiction. We have no reason to doubt the likeness of this convincing portrait.

Baroque art developed around 1600 as a reaction against the formulaic Mannerism that dominated the Late Renaissance. Less complex and more realistic, it was developed by Caravaggio, Bernini and Carracci, among others. This was also the age of Rubens, Rembrandt, Vermeer and Velázquez.

This drawing is a fine example of traditional red, white and black chalk drawing. I liked this drawing so much that I was inspired to attempt the tricolor technique myself with the portrait of "Jessica" on page 119.

Portrait of Galileo
Ottavio Leoni (1578-1630)
Chalk drawing in three colors
Biblioteca Marucelliana
Florence, Italy

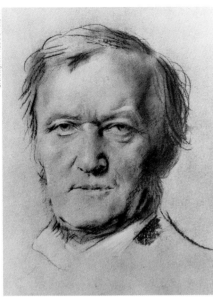

An Expressive Portrait

This head study of composer Richard Wagner is from the Realist movement and was completed by celebrated portraitist Franz von Lenbach, who became an important society personality in late nineteenth-century Munich. Although the portrait appears deceptively simple at first glance, its unique anatomy and expressive realism is from a highly skilled hand. The study is so realistic that it seems as though Wagner himself is peering out at us.

Portrait of Richard Wagner
Franz von Lenbach (1836-1904)
Chalk drawing
Richard Wagner Museum
Bayreuth, Germany

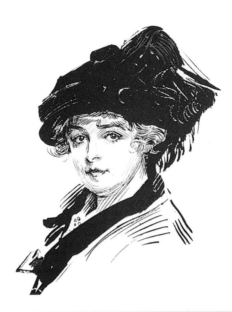

A Charming Illustration

A beloved artist from the Golden Age of Illustration, James Montgomery Flagg was a master of many styles and techniques. I grew up admiring his wonderful illustrations. This ink drawing from 1914 relies on just two values, black and white. The complexity of the model is apparent despite the illustrative nature of the portrait. I was charmed when I first saw this skillful and stylized drawing, because it so clearly conveyed the personality of the sitter. I only recently learned that it was of his wife, Nellie.

Drawing of Nellie
James Montgomery Flagg (1877-1960)
Ink
Courtesy of the James Montgomery Flagg estate

A Confident Sketch

This study was drawn by Flagg's friend and protégé, Everett Raymond Kinstler. Flagg passed away when I was just two years old, but when Ray shared stories about their friendship, I felt a part of an art continuum. Many artists of my generation have been encouraged and inspired by the work and writings of Raymond Kinstler, once he stepped into the roll of mentor.

The expertise and confidence that is revealed in this quick sketch is undeniable. And even though I will never know Flagg, I suspect this study captured his likeness, and presence, perfectly.

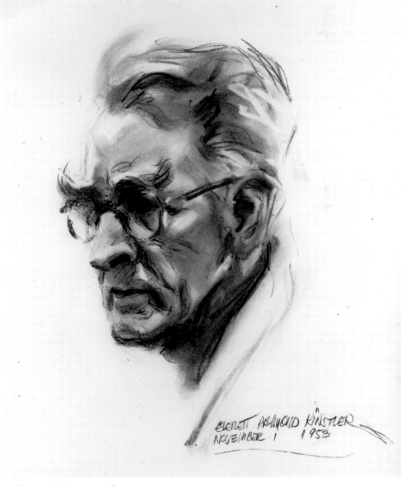

Drawing of James Montgomery Flagg
Everett Raymond Kinstler (1926-)
Courtesy of Ray and Peggy Kinstler

TOWARD A NATURALISTIC STYLE

All the categories of art are worth knowing. In this book, we are seeking a more naturalistic style. This style is born from an understanding of all the styles that came before it: symbolic, stylized, idealized and realistic drawing.

The use of *symbolic drawing* typically indicates that an untrained or provincial hand did the work. My 18-year-old son is an accomplished athlete and a good student, but he is not an artist. When asked to draw a human face, he obliged with a childlike drawing (below). As would most lay people, he used *feature symbols* when drawing a human face. For example, the eye is drawn as a football shape around a dark circle and topped off by a row of radiating lines for eyelashes, a common feature symbol for an eye.

After a brief lecture about basic anatomy, the patterns of light and dark and "gestalt" thinking—all of which we'll discuss in this book—he was able to draw the second drawing (below). While not a masterpiece, it's a vast improvement over the first and strong step toward really understanding how to capture a likeness.

Symbolic drawing also appears in tribal works and pieces from antiquity, as well as in contemporary works created by artists exploring symbolic drawing in a conceptual way. In the case of contemporary artists, though, symbolic drawing often develops into stylized drawing.

Stylized drawing can be found among many works through the ages. Egyptian and Roman portraits were often stylized, as were many Asian works. The Golden Age of Illustration of the late 19th and early 20th centuries saw a proliferation of trained illustrators creating charming etchings and drawings, frequently in a stylized manner. Newspapers and magazines often feature highly stylized figure works created by comic strip illustrators and other cartoonists. Many contemporary illustrators continue the tradition. Children's books are common venues to see such stylized work.

Mason's First Drawing
The use of symbolic drawing typically indicates that an untrained hand did the work. My 18-year-old son is an accomplished athlete and a good student, but he's not an artist. When asked to draw a human face from memory or imagination, he obliged with this childlike drawing. Like most novices, he used feature symbols when drawing a human face.

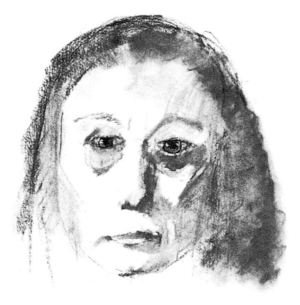

Mason's Second Drawing.
So, after a 15-minute lecture about basic anatomy, light/dark patterns followed by a quick portrait demonstration, my son adjusted his way of thinking and agreed to start over using a naturalistic approach to capture the "gestalt" of the sitter (see page 30).

Artists from ancient Greece through the Twentieth century frequently practiced idealized drawing. Artists produced portraits in which they had removed blemishes or enhanced bone structure, and idealized figures and features based on particular canons. The European art academies first established in the Renaissance trained their students to the highest level of draftsmanship, but also required them to create idealized narratives, working in expressions, gestures and settings to elicit specific emotions. The French Academy established an actual hierarchy for art: classical, religious, mythological, allegorical and other idealized narratives were considered more important than scenes taken from everyday life.

Early Realist movements began in the 18th century as a reaction to this formulaic and idealized style. The artists of the Realist movement used the skills they had acquired through formal training and aspired to capture their subjects as they actually appeared, without excessive idealizing.

Today, artists have complete freedom to draw portraits as they please. There are no hard-and-fast rules and no strict requirements for membership into current portrait societies, guilds or registries. The question of whether one is a trained portraitist with a working knowledge of anatomy, perspective, contour and form is something of a moot point, as whimsically crude portraits and portraits done from photos or projected images are as likely to win recognition as those done from life.

In spite of these obstacles, the past two decades have seen a growing demand for information about traditional drawing and artists demonstrating an ability to draw from life are respected by their peers and are sought out by collectors.

Symbolic Stylized Naturalistic

Three Trees, Three Ways

Each of these drawings depicts a tree with branches. One tree is drawn symbolically as a hieroglyph or symbol. The stylized version is decorative and appealing for its design merits; it might be used for a wallpaper or fabric pattern, for example. The final naturalistic rendition was drawn while making observations from life.

Working in a symbolic or stylized way can be fun and rewarding. In fact, it can be so much so that one might be tempted to forego the discipline and frustration associated with mastering a naturalistic approach. However, in order draw convincing, realistic portraits, the accomplished artist must be skilled at realistic drawing. The good news is that, with appropriate information and lots of practice drawing from life, those skills are attainable.

GESTALT THINKING

The ability to create portraits and figure drawings that are at once convincing and aesthetically pleasing involves a vast skill set that includes gestalt thinking. *Gestalt* is a German word that means shape, form or figure. In a drawing, however, it means the total effect of the different parts might be greater than the parts themselves.

In founding the Gestalt Theory, Dr. Max Wertheimer stated that "what is happening in the whole cannot be deduced from the characteristics of the separate pieces." We can illustrate this theory by creating a "shape-map" or light/dark pattern to simplify a face. It proves how little information is required to make a face recognizable.

For the portraitist, this means learning to see and record in terms of unified wholes as opposed to compiling individual details. The properties of each person's face and figure are so unified that we cannot execute a successful portrait by simply observing and recording separate features.

We can fill pages and pages with studies of skeletons, skulls, noses, eyes and mouths in an attempt to master portrait drawing, but in the end, each sitter presents new shapes, shadows and planes that relate to one another differently than anything ever seen before. Observing and recording those relationships and applying your knowledge of formal elements like shape,

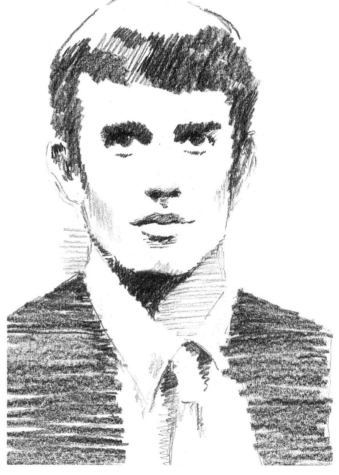

Massing In the Shapes

These two images show a shape map and the black-and-white photograph I have created it from. Black-and-white photographs help simplify values and obscure distracting details, but you can simplify the image even more by squinting as you look at the photos.

Based on the photo, I drew this shape map. I placed, or "massed in," the largest dark values according to the simplified image. As I proceed with the finished portrait, I'll add more details and tonal variation, but the large masses of value do a good job of communicating volume.

value, line, mass, texture and color enable you to create the illusion of form, an illusion the viewer perceives as the gestalt of a specific individual.

Massing

Massing is the blocking in of large shapes of value (light and dark). It's used to describe form and volume through tonal value instead of line. As you can see from the illustration on the opposite page, massing in value—or creating shape maps—is a good way to trigger gestalt thinking. These smaller, indistinct shapes link to make up the larger picture. Each area of dark tone means nothing by itself, but when pieced together, the group of shapes presents a cohesive image. Your brain grasps the image instantly; it does not slow to "interpret" line or feature symbols. I start most of my portraits by looking for these values and massing in a shape map.

Massing is also useful when employing the sfumato technique. Sfumato consists of fading one tone into another, resulting in smoky value transitions and subtle lost edges. For a look at how one great artist used these ideas, research Georges Seurat's charcoal drawings; they are excellent examples of massing and sfumato.

To mass in your portrait, squint at the subject to simplify the values, then evenly apply areas of broad tone where you see the darkest darks. The first tone serves as the middle value, then the values can be pushed to achieve rich, velvety darks and subtle gradation.

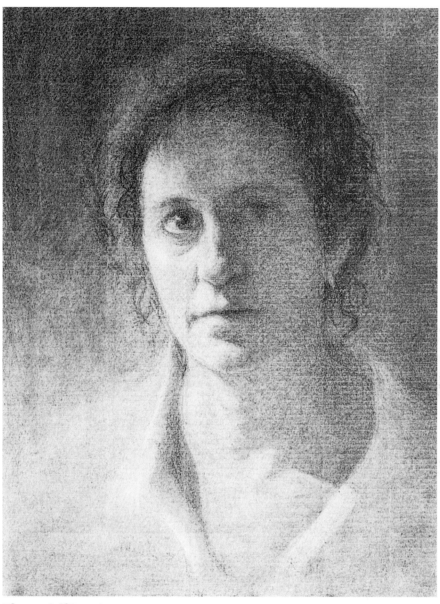

Sfumato Self-Portrait
This is my reflection looking in a mirror with a single light source to one side. I wanted to evoke a sense of mystery with lost edges and obscured features.

I heavily toned the entire surface with vine charcoal and massed in the darks with compressed charcoal. Then, I worked subtractively (that is, I subtracted tone by lifting it with a kneaded eraser) to create the light shapes. I was careful to maintain a sfumato effect, creating a smoky quality in the shadows. When working in areas heavily toned with charcoal, Conté or pencil, subtractive drawing is a good way to model the form and create highlights.

My self-portraits are always rather dark and dramatic like this one. Perhaps I want to portray myself as the stereotypical artist—soulful and intense. I am actually quite fun-loving and even a little goofy, according to those who know me.

Chiaroscuro Self-Portrait
Charcoal

COMPOSITION AND DIVINE PROPORTION

The concept of the golden ratio is, "The whole is to the larger as the larger is to the smaller." The golden ratio = 1: 1.61803399. The golden ratio is also known as the golden mean, the golden section or the divine proportion.

The geometry of the golden ratio can be found everywhere in nature including snowflakes, shells of invertebrates, the growth pattern of plants, geometric molecular and atomic patterns of solid metals, fingerprints and even DNA. Throughout history artists have recognized the golden mean in anatomy and nature and were taught to utilize the ratio 1:1.618 as they designed their drawings, paintings,

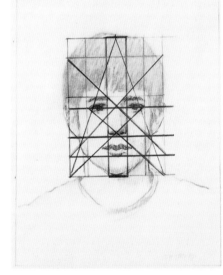

Faces of Phi
Phi has long been associated with human beauty, since the most attractive bodies and faces exhibit an abundance of the golden ratio. This applies to the canons of the head when comparing the width of the mouth to the width of the nose; once again, the ideal ratio will be 1: 1.618. The distance from the chin to the eyebrows will ideally divide the face in a golden ratio and so on. The human face contains many golden rectangles and triangles; we need only to look for them.

sculptures, jewelry, utensils and buildings. Musicians and writers also learned to apply it to their compositions.

The "number" is represented by the Greek letter *phi* (not to be confused with another famous number, *pi*). It's a numerical constant that relates to mathematics, biology and art. It's an irrational number that cannot be expressed as a fraction, and goes on forever without repeating. The ratio of 1 to 1.618 is the simplest form of the acclaimed divine proportion.

Used by the ancient Greeks to design buildings and monuments, and by painters like da Vinci, Seurat and Dalí to compose their paintings, the golden ratio reflects a balance of symmetry and asymmetry. Aesthetically pleasing works of art are often defined by the golden mean. In fact, studies show that works of art that agree with the golden mean are far more preferred. In other words, if you paint two landscapes, one with a boat smack in the middle and the second with the boat on one of the "sweet spots" as determined by the golden ratio, viewers will invariably prefer the later.

To find the golden ratio of a line, divide a line into two unequal segments so the shorter segment is to the longer segment what the longer segment is to the whole line. Create a golden rectangle from this by extending the long line segment into a square and extending the short segment into a rectangle beside the square. The sides of a golden triangle (an isosceles triangle with a vertex angle of 36°) are in a golden ratio to its base.

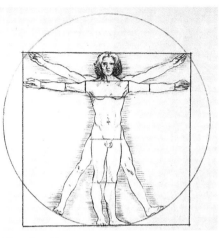

Vitruvian Man
Canons of the human body that measure from the feet to the navel, then from the navel to the top of the head, usually reveal the second measurement as a ratio of 1: 1.618 to the first measurement.

The golden ratio forms the basis for da Vinci's "Divine Proportion," as illustrated in my study of his drawing of Vitruvian Man. The extended limbs of the human fit into both the circle and the square. The relationship between the circle and the square in this drawing adheres to the golden mean as the length of one side of the square is 1: 1.618 times the radius of the circle. Although made famous by da Vinci, the concept of the Vitruvian Man was actually created by the Roman architect Vitruvius.

Study After the Vitruvian Man
Ink and graphite on bond paper

You can use the golden ratio to divide your paper and find the natural focal points, or "sweet spots" as illustrators call them, on your paper. These sweet spots are a natural place to put your center of interest or other supporting points of interest.

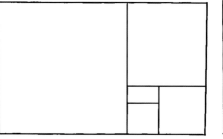

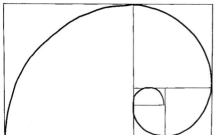

Divided by the Golden Ratio

A rectangle is "golden" when its width and length are proportional to the golden ratio. This rectangle is divided into smaller and smaller portions according to the golden mean. A golden rectangle can be partitioned into a square beside a smaller rectangle of the exact same proportions as the original rectangle, which can be partitioned into a square beside a smaller rectangle of the exact same proportions as the original rectangle, which can be partitioned into a square beside a smaller rectangle of the exact same proportions as the original rectangle... and so on, into infinity. Get it?

The Eye of God

When you remove a square from one side of a golden rectangle, the remaining rectangle will also be golden, with the same proportions as the original. This process can continue infinitely. Draw diagonals across any pair of these rectangles and they will always intersect at the same point. Keep removing squares from the same end, and the whirling rectangles can then be inscribed with a logarithmic spiral also known as an equiangular spiral. The limit point of the spiral will be the same as the intersection point of the diagonals. This point is commonly referred to as the "eye of God."

Finding the Other "Sweet Spots"

Repeating the spirals on all sides will give you four focal points or "sweet spots," as illustrators like to say.

Making Use of the Concept

We can use these concepts to determine proportions and placement through a standard grid. The use of this grid is not limited to a golden rectangle, it works with all shapes. With a few steps you can create (or imagine) a grid to suggest direction, columns of interest, horizon lines, focal points and much more.

The key is to make this grid by first drawing diagonals, then draw midlines to create quadrants, each one equal to the whole. Then divide each of the quadrants just as you divided the whole. (See how the concept works?) The intersections will provide the saddle points or sweet spots. Of course, this dividing and subdividing can literally go on forever, revealing more tangents and sweet spots. The number of composition and design possibilities based on this method would be, well, endless.

PROPORTION AND DESIGN

You can use grids to design according to phi. Simply use the concepts of the phi to spark your imagination and to help you see the world (and the flat surface of your paper) in terms of ratios and proportion.

The two sketches shown reveal ratios at work. The relative sizes of the planes and shapes, the placement of important elements at the sweet spots, and the balance of symmetry and asymmetry help make these sketches successful. These are just quick studies, but their pleasing proportions give me the green light to pursue something more final.

At first, you may need to sketch grids on your paper with vine charcoal. With practice, you'll naturally visualize the division of space. Even if you have a natural sense of composition, it's fun to study the fundamentals and try different methods of composition.

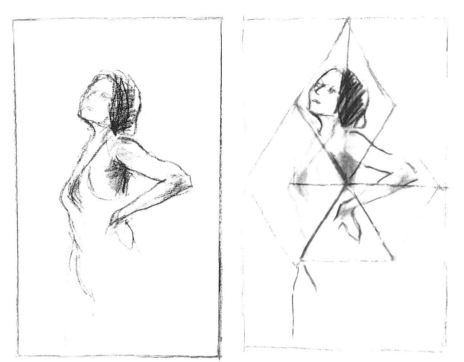

Three-Minute Gesture Drawing
I've always liked this simple gesture drawing. A quick analysis using a grid based on the Golden Ratio reveals an interesting composition. The figure is placed within a diamond, along the diagonals and within triangles as defined by the grid.

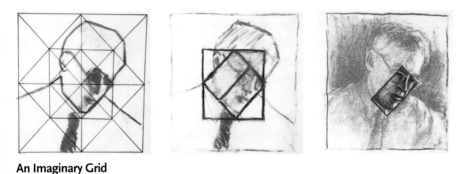

An Imaginary Grid
Although I didn't actually draw this grid, I imagined it in order to plan the placement of the head and the off center lead-in of the tie. The center of interest (the face) is contained within a rectangle as defined by the grid. The asymmetrical placement, the ratio of the variously sized shapes and the arrangement of these shapes all correspond to my imaginary grid.

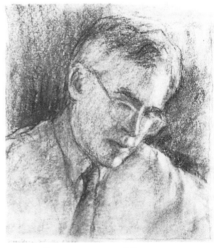

Study of the Secretary of the Navy
This charcoal study from life was done as a preparatory sketch for a portrait commission.

In all perfectly beautiful objects there is found the opposition of one part to another and a reciprocal balance.

JOHN RUSKIN

THE CANONS

Classical artists made it their business to apply established anthropometric systems of measurement, or canons, when depicting the human form. The ancient Greek and Roman artists, as well as Renaissance artists, depended on such canons to determine the proportions and dimensions of the human figure. In a canon, each unit of measurement is called a *module*.

Two of the more famous canons, the canon of Polykleitos (c. 450-420 B.C.E.) and the Apoxyomenos of Lysippos (c. 370-330 B.C.E.), used the head as the unit of measure, or module. In the canon of Polykleitos, the ratio of the head to the body was 1:7, so the body was seven heads tall.

Various canons were used through the Renaissance and later to depict people in a different light. The three most frequently used were *heroic, ideal* and *ordinary*.

In the heroic canon, the human figure is eight and a half heads tall. To this day, this canon is often used by comic strip illustrators to create "larger than life" superheroes.

The ideal canon was often used by painters creating allegorical works or commissioned portraits of powerful people. This canon shows people as eight heads high.

The ordinary canon—seven and a half heads high—is used for lifelike portraits of real people and is the preferred approached used by realists drawing in a naturalistic way. The early Realists popularized this canon in the eighteenth century as a reaction against the formulaic, idealized canons used at European academies.

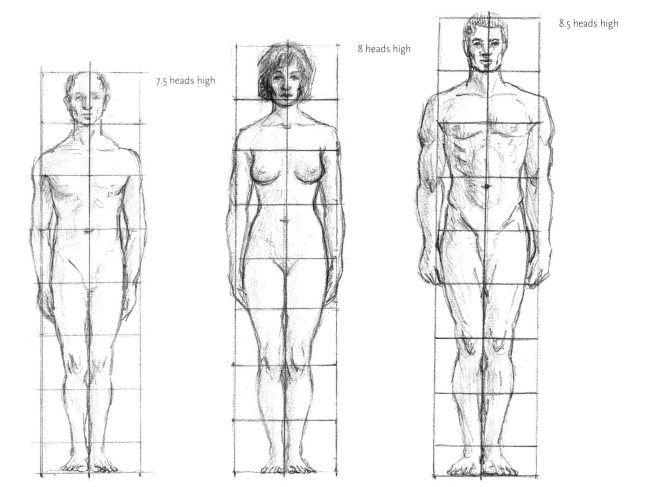

7.5 heads high

8 heads high

8.5 heads high

The Canons
From left to right, these figures depict the ordinary canon, the ideal canon and the heroic canon.

Systems for Measurement

For a portraitist, measuring is crucial. It's as important, in fact, as the gauging of values or the quality of line. A measured grid based on the golden mean will divide the space and guide placement. Measuring will reveal the subject's proportions.

My most influential art mentors frequently used the term "out of drawing" when giving a critique. With time, I realized that they were speaking in the Renaissance sense of *disegno*, which includes both drawing and the design. If something was "out of drawing," the proportions in particular or the design in general weren't working. The best pictorial compositions provide the viewer with evidence of the artist's understanding of the picture's elements and of an ability to execute a cohesive plan.

Sight-Sizing

The sight-size method is a traditional system of measurement employed by portrait and still life painters for many centuries. With this method, the artist sets the easel next to the model on the exact same plane. The artwork and sitter will appear exactly the same size when viewed from a distance. Measurements of the model are taken with calipers for transfer to the support. The artist then walks back several feet in order to view the subject and the image side by side, walking back to the work to make adjustments. The process is repeated again and again. In this manner, the "gestalt" of the subject is captured as the piece is completed to scale or as "life size."

Other methods of sight-sizing involve placing the easel at a distance away from the subject, then transferring onto paper the exact measurements as seen through a view finder or tracing the exact image onto a piece of glass or other transparent material in order to copy the image exactly as it appears at that particular distance.

The Comparative Method

With the comparative method of measurement, you simply measure and compare lengths, proportions and angles of particular planes or features. You use the size and placement of one element to determine the size and placement of another. Essentially, you create your own canon. This method works well for all manner of subjects, including full figures, still lifes and landscapes.

To take a pencil measurement, stay in one spot while holding a pencil at arm's length with your elbow locked. Shut one eye to "sight in" on the subject, then slide the thumb along the pencil to mark a particular unit of measure. Keep your arm locked while maintaining the same standing or seated position. Then move the unit of measure along imaginary horizontal or vertical lines to make comparisons.

One advantage to the comparative method is that it gives artists the freedom to determine the scale of the image, despite the proximity of the subject, as opposed to the sight-size method.

Let's say you have the misfortune to arrive late to a portrait drawing workshop and find yourself at the very back of the room. The use of sight-sizing will lead to a miniature portrait because you must transfer the actual measurements as they appear. Imagine then that you prepare for class the next day by bringing a small support suitable for a miniature, but then are assigned the spot nearest to the model. Now your support is too small for sight-size measuring!

With the comparative method, you decide the size. If the head of a portrait needs to be three times larger (or smaller) than what you actually see through sight-size, you simply:

1. Mark the top of the head and the bottom of the chin as looks best on the support, then (when working with an adult) mark the middle of that for the eyes.

2. Halfway between the eyes and the chin, mark for the nose.

3. Halfway between the nose and the chin, mark for the mouth.

Use the distances between the horizontal marks to determine widths. For example, the distance from the chin to the level of the pupils may be the same measurement as the width between the outside corners of the eye sockets. Divide that measurement by three to determine the width of each eye (since there is typically a third eye's width between the eyes), then use the width of an eye to measure distances in terms of "eye widths." Ask yourself questions like, "Is the width of the eye equal to the width of the nose?" or, "When looking at the subject full-face, does the width of the nose equal the distance from the bottom of the mouth to the tip of the nose?" Make small marks on the paper according to your observations.

The proportions for the human head vary according to gender, age and other individual differences. This changes many basic measurements, but whenever you use a comparative

method to create units of measurement, the same principles apply—whether for full figure, still life or landscape. Follow standard measurements in the beginning, then look for the characteristics unique to the model.

Once you "find" the measurements that correspond to your work surface, continue "sighting" over the edge of your pencil to determine angles and slopes. Check the angles from the outside corners of the eyes to the edge of each nostril, for example. Then make sure all of the angles and slopes you find on the subject match those on your drawing.

Comparative Measurements

Here, I've made small marks according to my observations. After laying my initial placement marks (the top of the head, the bottom of the chin, the halfway mark for the eyes, as well as the nose and the mouth), I began to look for measurements and mark them on my paper. The distance from the chin to the level of the pupils is the same measurement as the width between the outside corners of the eye sockets. I divided the eye socket line into thirds, each section the length of an eye. In this case, the width of the eye is also equal to the width of the nose, and the width of the nose is equal to the distance from the bottom of the mouth to the tip of the nose.

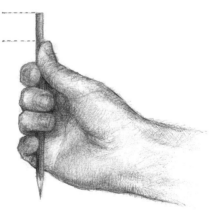

Measure Vertically

Measure Horizontally

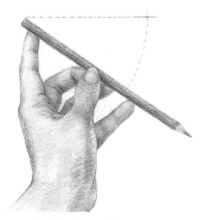

Check Angles and Slopes

BLOCKING IN AND LAYOUT

The methods of measuring proportion on the previous pages work like a charm when used in conjunction with a grid (or the idea of a grid). I combine these approaches for my hybrid "free envelope." These methods of blocking in are to be used with all of the other systems of measurement and placement to construct proportions. A good layout will empower you to move forward with confidence and certainty.

The Envelope Method

Creating an "envelope" around your subject can simplify the original placement of the picture, solving many problems associated with the initial blocking in of the composition. It can be especially useful when dealing with complicated poses. With this method, you measure the outermost points of the subject and then mark them on your paper, connecting the points by straight lines. The idea is to begin with one block or geometric shape that can be aesthetically placed according to any grid, and can be easily moved, enlarged or minimized. Just as a sculptor chiseling away at a block of stone, you must work to define the big, angular shapes before describing curvaceous limbs or languid expressions.

The Free Method

The "free" method is essentially gesture drawing. It's another traditional way of making that first statement on your paper. It requires that you keep your eye on the subject while you lightly swing the drawing tool around in a gestural manner, getting the "feel" of the proportions on the paper. Those who excel at gesture drawing may obtain a somewhat accurate layout using this approach of trial and error.

Take care to compare the sketch to the subject. It's a challenge to make corrections and stay "in drawing" while maintaining the loose, expressive quality of this method.

Some poses or environments will call for one approach over another. The advanced artist will have the skill set to use any or all of these methods. It is best to understand and practice all methods, then you can keep the options open.

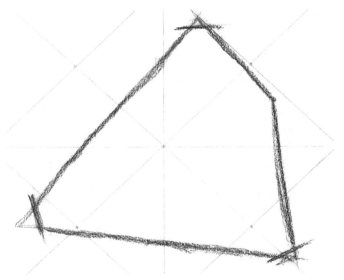

"Enveloping" the Pose
These methods are really only a means of thinking about a pose, but here I mark them on a paper to illustrate. For this drawing, I've marked the outermost points of the pose and connected them with straight lines. This "envelope" reveals the overall form.

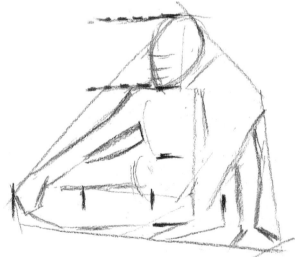

Finding a Comparative Measurement
I used the head as a unit measurement, asking myself, "How many heads wide is the pose? How many heads high?" I made corresponding marks on my paper and then subdivided the envelope by connecting these marks with lines.

The beginning is the most important part of the work.

PLATO

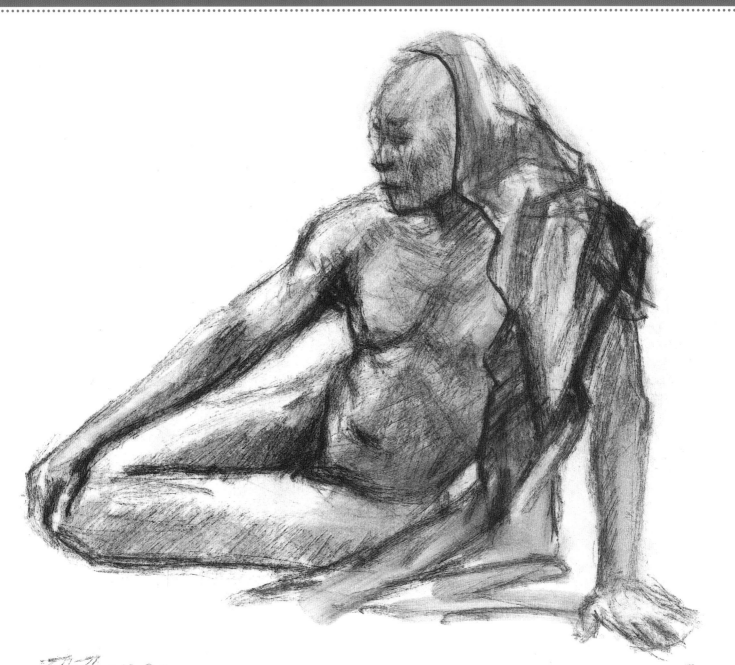

The Final Drawing
The initial lines became the bones of the pose. I was able to work quickly and loosely, capturing the spirit of the pose.

VALUE AND VALUE SCALES

Value is one of the formal elements of art. Simply put, it is the measure of relative lightness or darkness of a particular tone. Artists use value to depict form and luminosity.

A good realistic drawing depends on a range of values. Even if your plan is to maintain a very close value range, with all tones high key (an overall light drawing) or low key (an overall dark drawing), it's important to remember to include a range; there still needs to be an obvious variation from lightest light to darkest dark. This isn't to say that the transitions from one tone to the other cannot be subtle, as with the sfumato technique; it just means that the transitions need to describe a noticeable shift from light to dark, and vice versa.

One way to become adept at creating value ranges that describe shadows, halftones, highlights and reflected light is to practice making value charts. It also helps when comparing different drawing materials.

When gauging values, try to employ this rule of thumb: Nothing in the shadows, not even the lightest value there, can be lighter than any values in the light shapes. The idea is to assign values and then prevent them from becoming fugitive from their place on the overall light/dark shape map.

Think of gauging values in terms of setting up a game of tug-of-war. You can see this idea at work on a value scale; one end is light, the other is dark, and, except for the exact middle, all of the other values belong to one side or the other. You must determine the exact middle and keep all of the other values on their appropriate light team or dark team.

Creating Form With a Range of Values
The white circle on the dark background has shape, but no form. The same can be said of the dark circle on the white background. The circle in the middle, with its range of values showing shadows and highlights, looks realistic.

Pencil	Compressed Charcoal	Pen-and-Ink	Ink Wash

Value Scales in Four Mediums
These value scales show the gradation of value, from dark down to light, of four mediums. If you compare them, pen-and-ink has the darkest value, followed by compressed charcoal and ink wash. Graphite is the lightest at the dark end of the value scale. Each medium, however, can represent a full range of highlights and shadows, light areas and a dark areas, when used to compose a portrait. The contrast of darks and lights, and the presence of a full range between, can make for an interesting drawing.

NEGATIVE SPACE

Shapes are vital to gestalt thinking. It's the shapes of light and dark, that contribute to the drawing to create the final image. This includes the *positive space*—the shapes that make up the sitter's form—but also *negative space*. Negative space is the empty area that exists around positive shapes.

When drawing negative space, look for the shapes formed by the space around, or between, different elements of the subject. The positive form will emerge as you draw the negative shapes. Attention to the placement of negative space is very important to the overall design of a composition. It can be a way to plan a larger pattern that relates to the golden mean.

The examples below illustrate how to think about, and ultimately see, negative space.

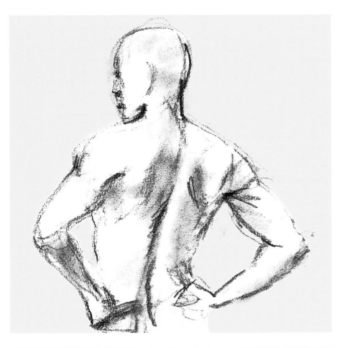

Using Negative Space

The large negative space here between the model's arms and his torso, as well as the general background surrounding him. In keeping with the Gestalt theory, these negative shapes—as well as the positive—add up to the whole image. They reinforce the overall pattern of the composition, too.

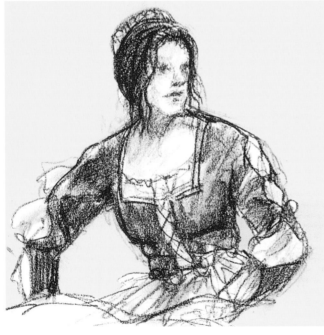

Variety of Size

This sketch of a woman in costume has interesting negative space. The primary areas of negative space are again between the arms and torso. These spaces say a lot about her pose and gesture, as well as the artist's viewpoint. Negative space may be lighter, darker or of a similar value to the subject. In this case, the negative space is in stark contrast to the figure and provides an interesting counterpoint to the dark values of the costume.

But not all negative spaces are this large. Notice where the model's hair falls in locks around her face? The area of background you see through these locks is also negative space. Though smaller, they help echo and repeat the patterns throughout the composition.

STUDY OF ANATOMY

You need to become somewhat familiar with human skeletal structure when drawing people. It doesn't take long to acquire the basic knowledge needed to locate and "see" the bone structure as you work with models. Purchase a pad of newsprint and fill the pages with one-, three- and five-minute studies.

Ideally, you will find the perfect anatomy class with the perfect drawing teacher. In case you don't, the next step is to obtain an articulated artist's manikin from an art supplier along with a few anatomy books and how-to art books from the nearest library or bookstore. Perhaps a health department, hospital, university or even your doctor will make arrangements for you to draw from a skeleton. Drawing from anatomy books and manikins, while adhering to human canons, will introduce you to the human form. You can also purchase a skeleton from a medical supplier (or a resin skull at least) and then make lots of skull and bone studies. Keep the skeleton and manikins on hand to compare to live models later. Visit museums, look at art books and do some online research to study figure drawings by other artists.

Hang the Flesh

After drawing hundreds of skulls-with-spines and matchstick figures, you should be ready to try your hand at "fleshing out" your drawings by drawing nudes and clothed figures. Anatomy books, again, make good reference tools when learning to draw muscles and cartilage. Working with nude models is a basic requirement for acquiring the necessary skills to paint and draw the clothed figure later, so if you have art guilds nearby, start attending their open-drawing sessions. You can also organize a "sketch club," and then members can share the cost of a model or take turns modeling for each other.

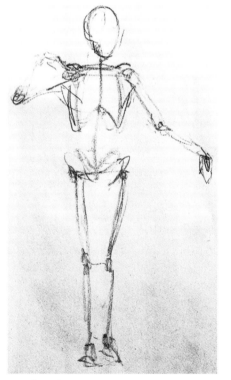

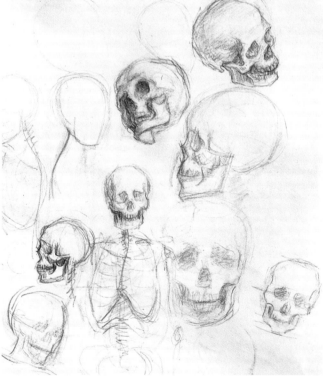

Matchstick Figures
Once you have a model and are prepared to draw, set a timer and have the model change poses every few minutes. Rapidly depict the model in a skeletal way, drawing only the skull and spine for the first hour or so, then adding the ribcage, then the pelvis. It's important to study the angles at which they are set. Finally, add the limbs for pages of matchstick figures. Purchase several big pads of newsprint and draw hundreds of figure studies in this manner, adhering to the ordinary canon. At the end of each session, date the first and last drawing so you can chart your progress over time.

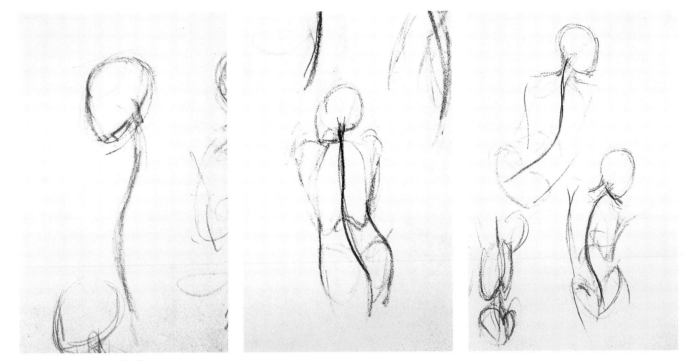

Place the Spine and Skull

Begin with the "teardrop" of the head as it relates to the spine. Ask the model to move about so you can find the "line of action" in the back. Work swiftly, spending only thirty seconds or so on poses of this nature.

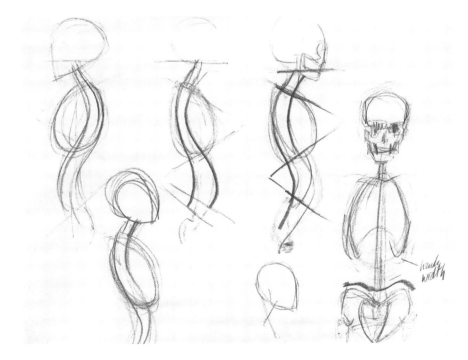

The Shapes of the Body

Understanding the basics will make it easier to add the rib cage and pelvis to your studies. Take note of the how the angles of the shoulders, ribcage and pelvis relate to one another and to the spine and skull.

The spine supports the cranium just behind the ear hole and mandible. It has a pronounced S-curve leading down to the tailbone. The ribcage seems to cantilever or hang from the front of the spine. Typically, there is one hand's width, or less, between the ribcage and the hip. Note the pelvis is heart-shaped, and the ribcage is like an egg with a horseshoe negative shape at the base.

CONTOUR DRAWING

Contour drawing depicts form by outlining the edges. Like many artists, I now rely on a combination of formal elements such as line, value, and form to craft my drawings, but when I was a beginner I always drew with outlines.

Masterful contour drawings are appealing for their design and calligraphic elegance. We look to past artists like Holbein the Younger or Ingres for good examples of contour drawing in portraiture. It's undeniable that line plays a crucial role in drawing, and that the quality of the line makes all the difference. Working on profiles is a good way to practice contour drawing while honing your measuring skills. Try varying the thickness of the line to provide the illusion of weight and volume in your contour drawings.

Blind Contour Drawing

Blind contour drawing is a popular eye-hand coordination exercise in which one draws the outline of the subject using a single continuous line, but without looking at the paper. It teaches the importance of keeping your eyes on the subject instead of the drawing. When practicing blind contour drawing, imagine that your eyes are following the slow path of an ant as it travels along the outside edge of the subject and that your pencil point is moving in exact unison with the ant on that path. It's actually easier than it sounds and the results can be amazingly accurate, or at least very amusing. Novices typically make better drawings using this method than any other because they are finally drawing what they actually see, as opposed to drawing what they think they know.

Making lines that go across the

form, revealing the topography of the surface, is called cross-contour drawing. For an example of this, take a dol-

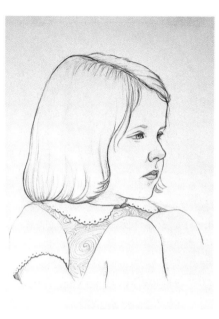

lar bill out of your wallet. The etched portraits you see on paper currency rely on this technique.

Contour Portrait of a Child

It is against my nature to work in line when I draw and paint. My oeuvre reveals an interest in volume and mass. I depend on shapes and gradations of value, as opposed to line, when crafting my images. Having said that, I believe it is good exercise to practice other techniques, this drawing required a lot of restraint on my part, to create a portrait using only line.

Contour Profile of a Child
Graphite on bond paper

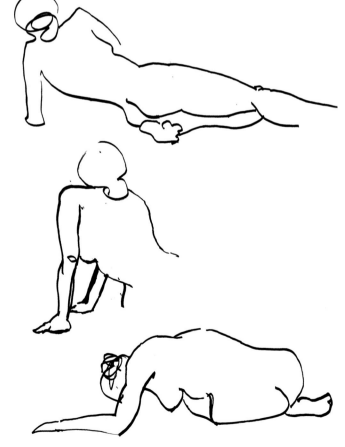

Blind Contour Drawings

This is from a series of very rapid blind contour drawings. I remember being proud (and amazed) at how well the page turned out. In the past, I've pulled out these studies in an attempt to show off to visitors. After explaining what blind contour is, I expect to receive gasps of awe. I must report that the responses actually range from dull silence to raised eyebrows or shrugs. So don't get your hopes up that others will always appreciate your good efforts. The important thing is to continue working and practicing.

GESTURE DRAWING

The overall appearance of a person is the first thing you see. Once that impression has been "apprehended," you can break the form into separate parts to be studied in depth. Gesture drawing is a way to capture this first impression of form and movement on the paper. Gesture drawing is to a finished figure painting what a haiku poem is to a novel.

Gesture drawings are done from life. Depending on the exercise, a model holds a pose for a time, anywhere from thirty seconds to five minutes (never more than ten minutes). Artists describe the line of action of the pose and note additional elements as ability and time allow.

Gesture drawing on a regular basis will help develop your ability to record the subject's gestalt without getting caught up in the details. And while it's true that learning to draw faces is imperative, the portrait artist must also master full figure, three-quarter, half-figure and multiple figure portraits. Gesture drawing is a good way to learn to see the whole body.

To the beginner, gesture drawing will seem like a frustrating and somewhat mysterious process. After all, everyone keeps running out of time with those thirty-second poses, and the results often appear crude. As with any skill, it takes lots of practice to consistently achieve graceful gesture drawings. The idea is to use gesture drawing as a means to internalize the mechanics of elements like shape, value, line, mass and texture through study and repetition, so that the act of drawing can be performed automatically.

The process is similar to that of driving a car. The beginner is simply overwhelmed with actions to perform, rules to think about and outside influences. Student drivers are usually awkward and hesitant. With practice, the student internalizes the knowledge and reaches a state of mind commonly called "the zone," in which driving becomes automatic.

To an artist, the zone is a place where instantaneous decisions can be made, drawing issues seem to resolve themselves, and the artwork simply appears, as if creating itself. At those times, artists work with what appears to be little or no effort, but the truth is that most artists attain this level through hard work and practice. Once they've internalized one skill set, they push themselves to the next challenge or the next technique. Mastery is an ongoing process.

Gesture Drawings
These gesture drawings were done in under eight minutes. I set a timer to force myself into gestalt thinking so I wouldn't focus on the details. I had to work quickly to record my impressions of shape, value, line, mass and even texture.

MOVING AND UNPOSED TARGETS

While the discipline of drawing portraits in a formal sitting is important to a portrait artist's training, it's also crucial to practice drawing rapid portraits in natural settings without attempting to pose the subject. Drawing people as they go about their daily activities is a true skill-building exercise.

Relatives and friends are good subjects to begin with. Select a time when the subject is engaged in an activity where they can remain relatively still or stay in one spot while carrying out repeat movements. Activities might include knitting, ironing, washing dishes, reading, talking on the phone, rocking a baby, waiting for a bus or just sleeping.

Drawing Mark at Work

I spent the day with Mark and his family as they were sculpting relief designs to be used as architectural details in a building project they were working on. I liked the sense of concentration communicated through this pose, so I took the opportunity to sketch as Mark carved. Later I completed a traditional charcoal portrait, but his wife preferred the first one.

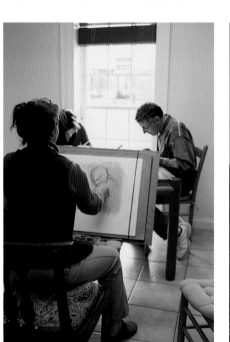

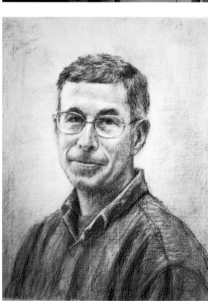

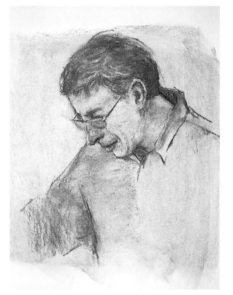

Mark Sculpting
Charcoal on sketchbook paper

Charcoal of Mark
Charcoal and white chalk on Fabriano Roma paper

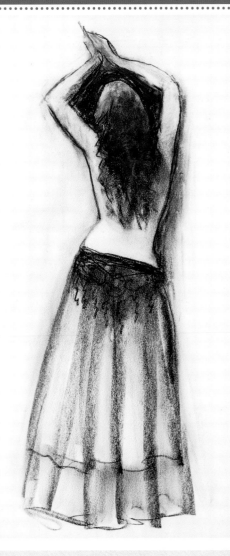

Belly Dancer in Motion

During an advanced drawing workshop, the instructor hired this amazing belly dancer for our class. Artists gathered on all sides of the model stand as she slowly rotated around while dancing. She took great care to repeat the same movements at the same spots. I simply selected one gesture to capture. I saw it over and over as she rotated around repeating her dance moves.

Belly Dancer
Charcoal on sketchbook paper

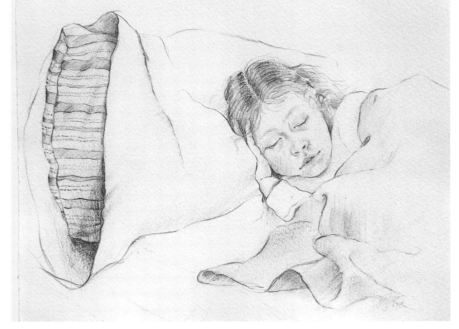

Naptime
Graphite on Arches drawing paper

Naptime

This study was done more than twenty years ago when I was a young mother attempting to keep up with a three-year-old and a one-year-old. It was very difficult to find time to draw then. On this day, both children were napping at the same time, so I abandoned my dirty house to draw my daughter as she lay sleeping. I was attracted to the graphic design of the ticking exposed at the edge of the pillowcase and to the "lead in" created by the bedcovers.

Working quickly, but carefully, this drawing was done entirely from life. It now serves as a memento of that period of my life, evoking the strong maternal feelings I experienced while watching my children sleep.

I also remember that I did not complete my chores that day... dishes, laundry, cooking and cleaning went by the wayside, as the children and I went on to spend the entire day drawing and "coloring."

LIGHTING

Lighting is a vitally important element in establishing the mood of a portrait. There are two sources of light, natural (daylight) and artificial (candlelight or lightbulbs). Both can be manipulated. Lighting may be direct, indirect, reflected or transmitted through translucent materials. Theater and photography suppliers have an extraordinary array of equipment for manipulating light, or you can use your own equipment with good results. Experiment with reflectors, curtains, flags, scrims and filters. Reflectors, walls, drapery or boards may be used to bounce secondary or reflected light into the shadows, and transparent fabrics can add wonderful subtleties to the light shining on the subject.

Natural north light continues to be the preferred choice of artists in the northern hemisphere. North light tends to be fairly steady with subtle shadows. South light tends to change more dramatically as the day wears on.

Spotlights are typically used as the primary light, or key light, when the artist's aim is use the bold contrasts of chiaroscuro lighting to model form.

I prefer ambient or natural light for my work. The exception would be my workshop demonstrations, when the use of a spotlight dramatically simplifies the form. Try a strong, directional light on the subject for the first attempts, in order to exploit dramatic shadow shapes and to establish a strong shape map.

Direction

The source of the light has a powerful effect on the presentation of your subject. Three-quarter lighting is probably the most frequent lighting selected for a portrait. It seems natural, and its direction produces clear shadows, which provide the value contrast and range necessary for depicting form. Other lighting can produce overwhelming shadows or distorted effects.

Rim Lighting

Rim lighting occurs when side or backlight creates a glowing outline that defines the edge of the subject and separates it from the background. Rim lighting is a dramatic way to employ the concepts of contour drawing.

One day as I walked by the parlor of our old house, I glanced in and saw my youngest son, sans shirt, sitting on an ottoman reading a book. He was catching a summer breeze while his profile was catching the radiant light, from a large open window.

This portrait was completed using just charcoal, white chalk and a kneaded eraser. I heavily toned the gray paper with charcoal to further darken it. Then the paper served as a middle tone as I used a kneaded eraser to lift and model the broad side of the face. The details were described in charcoal. Finally, the white chalk was added for an effective study of values.

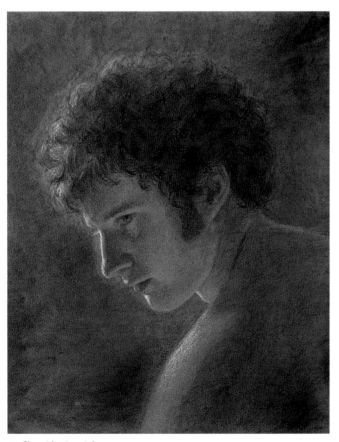

Profile With Rim Light
Charcoal and white Conté on Canson Mi-Teintes paper

CATCH LIGHT

Reflections in the eyes, called catch lights, can give the eyes a lifelike quality. Avoid overstating the catch light; it should be middle to light gray, not white. Some lighting arrangements omit the catch light, lending a pensive or mysterious mood to the portrait.

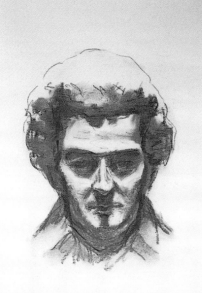

Top Lighting
Top lighting comes from above the subject, highlighting top-facing planes and casting extreme shadows.

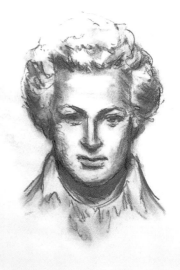

Bottom Lighting
Bottom lighting is commonly used in theater and cinematography for an eerie effect that distorts the features, making the subject a bit frightful in appearance.

Front Lighting
Front lighting illuminates and flattens the entire subject. It is used in commercial photography because the absence of shadow detail is thought to be flattering.

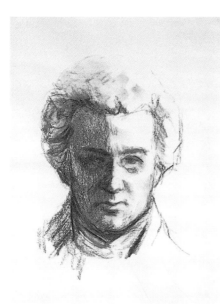

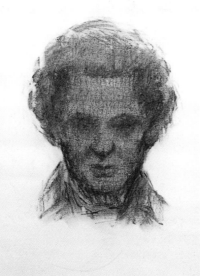

Sidelighting
Sidelighting, or split lighting, creates a dramatic chiaroscuro effect by illuminating just one side of the subject, leaving the other side in shadow.

Backlighting
Backlighting comes from behind the subject. It throws the entire subject into shadow, creating a silhouette.

Three-Quarter Lighting
Three-quarter lighting comes from above and at an angle. It is a standard in the artist's studio. It's identified by a triangular patch of light that appears under the eye, interrupting the shadow side of the face. The chiaroscuro effect creates a distinct shape map, while the cast shadows serve as a cross-contour across the form.

STANDARD POSES

Formal portraits are described according to how much of the subject is included. A list of poses would include full, half, three-quarter, head-and-shoulders and head studies.

Standard Head Poses

There are numerous ways to depict the human head, but a list of standard head poses include: profile, lost profile, three-quarter, full face and up-from-under.

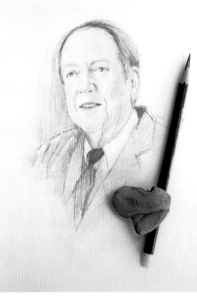

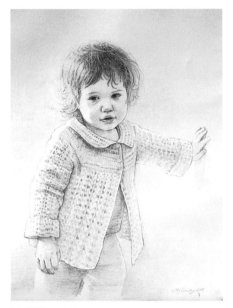

Full-Length Study
This sketch, a small thumbnail for a larger portrait, shows the full figure as well as a great deal of the interior. How the subject stands in the space and the objects in the room present a lot of opportunity for designing the composition and establishing a mood.

Head Study
This head study is more intimate and might capture more of the sitter's personality. It eliminates a lot of the potential distractions and provides a simple, clean and attractive composition.

Half-Figure Pose
The half-figure pose includes the figure to the knees. This drawing was done from photographs that I took of my clients' young daughter. The late afternoon light was beautiful but intimidating because I had never dealt with anything quite like it before. I was very interested in her sweet, bonny gesture and the complicated texture of the crocheted sweater.

Drawing of Toddler
Graphite on Rive paper

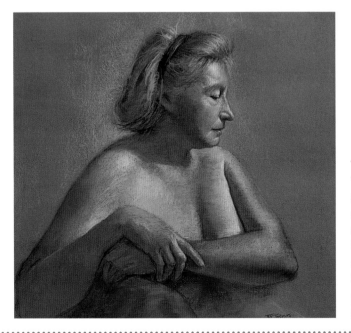

Three-Quarter Pose
Twelve years ago, I made arrangements for some of my students to spend a summer at the Lyme Academy of Fine Arts in Connecticut, and I got so excited about it that I decided to go with them. As the rest of the class drew with charcoal, I managed to complete this study from life with a limited palette. I still love this drawing; the lighting is beautiful and the three-quarter pose is sublime. I created several strong portraits with this model. She so fascinated and inspired me that I suspect she was a muse.

Jan's Shoulders
Chalk on Canson Mi-Teintes paper

FULL FACE

Full face, or *en face*, is the pose in which the sitter faces the viewer directly. The full-face pose seems to be the standard portrait pose. The symmetry of the pose can come across as static, but you can bring a lot of personality, energy or mood to the pose by altering it slightly. The full-face pose may include a tilt of the head, eyes in contact with the viewer or gazing away, and various forms of lighting.

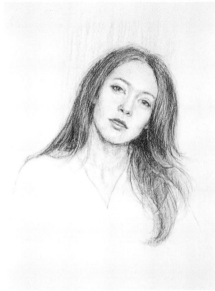

A Straightforward Gaze

My oldest child has done stints in college, the military and acting school. She has lived and worked in Europe, moved to the East Coast and then to the West Coast. When she came home for a visit recently, I was struck by her beauty and asked her to pose. I like the direct, flat lighting and the compelling expression of this simple portrait drawing. The tilt of her head and straightforward gaze suggests that she is attentively engaged with the artist.

The Artist's Daughter
Graphite on sketchbook paper

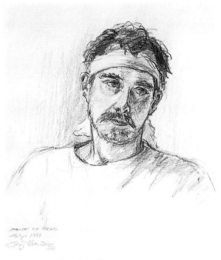

An Energetic Sketch

Our old farmhouse is surrounded by an enormous yard that's crowded with bushes, flowers, trees and eccentric outbuildings. We brave the summer heat and mow it with push mowers. Fred rips discarded T-shirts into strips to wear as sweatbands while mowing. I drew this quick study many summers ago, as he took a break from mowing to drink a glass of iced tea. Though it's full face, a lot of energy and motion is included in the drawing because of the tilt of Fred's head and the hatched lines.

Fred With Sweatband
Graphite on sketchbook paper

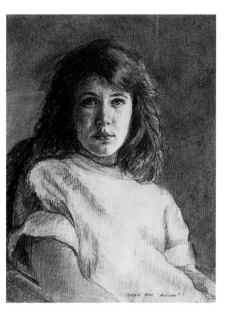

Shadowy Drama

Though the full face pose is standard, the chiaroscuro makes this drawing moody and dramatic. At one time, I created elaborate preliminary drawings like this for my painted portraits. Somewhere along the way, I abandoned that practice and just started direct painting. My portrait paintings go much faster now, but I miss having such nice drawings and studies to go along with my paintings.

Study in Chiaroscuro
Graphite on sketchbook paper

The body should not follow the movement of the head.

JEAN-AUGUSTE-DOMINIQUE INGRES

Three-Quarter and Up-From-Under

The "three-quarter face" is a pose in which the head turns to the side slightly. While both eyes can be seen (as in full face), only one ear remains in sight. One side of the face dominates the pose.

The challenging "up from under," or *sotto in su*, is a pose in which the subject is viewed from below. It usually results in extreme foreshortening.

Three-Quarter Pose
Shawn is one of my bankers and a friend. He and his wife are interested in art, and both have modeled for me. I took advantage of the afternoon light coming in through a window for the single light source of this drawing, to add more shadows and drama to the composition.

Study of Shawn
Graphite on bond paper

Up From Under
My youngest child was experimenting with growing his hair and beard. I was fascinated at the physical changes going on with him as he matured. He is college-age now, clean shaven with shorn hair. This drawing makes me miss his head full of curls and scraggly beard.

This unusual pose is not easy, but the results, as you see, can be very effective.

Mason
Charcoal on Fabriano Roma paper

PROFILE AND LOST PROFILE

"Profile" is a pose in which the head is viewed from one side. It's usually a very dignified pose but can be interpreted in other ways. A masterful profile portrait is always appealing and can be a bit mysterious.

It's also fun to experiment with other interesting poses, such as "lost profile," or *profil perdu*, in which the head is turned away from the viewer so that only an outline of the cheek is visible. There can be an intriguing subtlety to this pose. While it's not a standard portrait pose (indeed, you can't see the model's face), you'd be surprised at the strong reactions this pose can evoke.

A Relaxed Profile
I generally think pen-and-ink drawings are quite challenging, but I drew this study of my husband on impulse. While we were watching TV one evening, I picked up a felt-tip pen, located a scrap of paper in the mess on our coffee table and completed this pen-and-ink study in under twenty minutes. When I tossed it back onto the table and my husband glanced over, he said, "Wow, that's amazing, I had no idea you were drawing me... I like it!"

Watching TV
Pen and ink on scrap paper

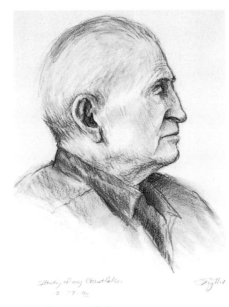

Study of My Grandfather
Graphite on sketchbook paper

A Dignified Profile
I drew this pencil study of my late grandfather as he watched television from a straight-backed chair. At some point, he became aware that I was drawing him and tried to hold his head up, but he just couldn't manage to keep his eyes open. His determination to remain dignified in spite of sleepiness, along with his big, aged ear, were the endearing traits I wanted to capture.

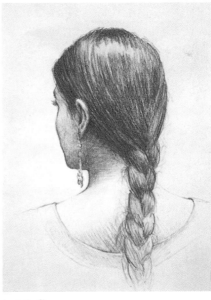

Lost Profile
Graphite on bond paper

Lost Profile
While sketching in the National Gallery in Washington, D.C., I spotted this young woman. She seemed flattered when I asked her to pose. She and her companions laughed when they realized that I intended to draw the back of her head! I was tempted to include the entire braid, which reached her waist, but I finally drew what had first caught my eye, the graceful sweep of her neck leading up to her cheek and delicate ear.

SETTING THE POSE

Getting your model into the pose you want can be difficult. You might find yourself saying "Tilt your head more... No, not that much. Well, more than *that*." It can be a frustrating experience for both you and the model. I've found that I can avoid confusion by teaching the sitter a series of hand signals to simplify setting the pose. This is especially important in an academic setting when using a model stand, studio lights, costumes and props.

My youngest son, Mason, helps me demonstrate (show at right):

1. The thumb represents the nose while the angle of the hand represents the axis of the head. Practice by asking the model to adjust the pose by following the slow tilt and turn of the hand.

2. The hand held level, parallel to the floor, represents the chin. Practice adjusting the tilt of the head by having the model follow as the hand moves up and down.

Ask your model to "lock their gaze" by looking at something specific. After you settle on a pose, mark the placement of your easel and the model's chair on the floor with chalk or masking tape. This way, if you take a break, it will be easier to arrange yourself correctly when you return.

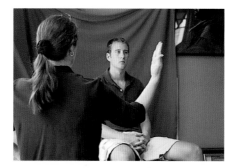
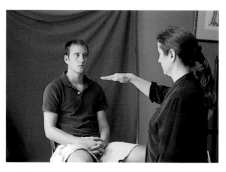
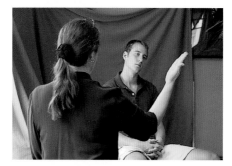
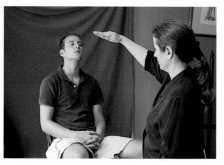
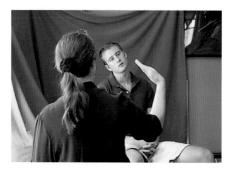
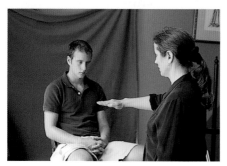
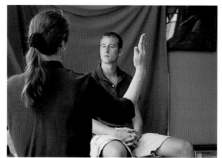
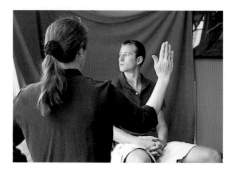

Positioning Your Model
Once I've stationed the model's head (left column images), I adjust the tilt of the chin (right column images).

NATURAL POSES

Even when you have some idea of the pose you want, forcing your model into a contrived or uncomfortable position will frustrate everyone. People tend to strike their best poses when they're being themselves, which is what you want to capture with a portrait anyway.

Launch into a conversation with your model by asking simple questions like, "What music do you like?" or, "Do you prefer summer or winter?" You may also broach questions about family, careers, hobbies or pets, as long as you are certain that the subject is comfortable discussing such topics. During the conversation, watch for characteristic gestures and expressions. Take note of interesting mannerisms. When you see an exciting expression or pose, command the subject to "Hold that, don't move!" for a quick sketch or photograph. Visiting the subject's home or workplace will also help set the mood of the portrait by providing ideas for clothing, props, lighting and overall composition.

Working from life is very exciting; it pulls the subject into the process while providing the artist an opportunity to develop strong drawing skills. Even when completing a portrait from photographs, you should schedule at least one sitting during which you work from the model. Allow two to three hours per sitting with plenty of breaks and lots of conversation.

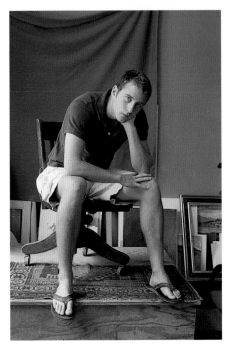

Natural Poses
Sometimes the best and most characteristic poses are assumed during breaks. Tell your model to "take a break," then step away and act busy. Secretly keep an eye on the model while moving props or adjusting lights. You may be inspired by what you see.

OTHER PEOPLE'S PHOTOGRAPHS

When using photographs, always insist on taking your own, unless you have accepted a commission for a posthumous portrait.

Working With Color

On occasion, a drawing will surprise us with the unexpected element of color. It has been said that color is the most emotional element of art because it affects our thoughts, moods, appetites and even our health.

Colors are defined by hue (the actual color, such as red), intensity (purity and saturation) and value (light or dark). A dark color is called a *shade*. A light color is called a *tint*.

Traditional colors used in drawing include sepia (brown), sanguine (red), white, gray and black. With the addition of Conté crayons and a couple of pastels in warm white, ochre, umber and cadmium red, you can create a limited palette capable of wonderful effects, especially when used with colored paper.

While color can add a lot to your drawings, its inclusion can be tricky. The key is to stay grainy and sketchy, especially when using pastel. Applying layers and layers of pastel is actually called "pastel painting," and while it is an amazing process, it is not the same as "pastel sketching," which typically allows some paper to show through.

Several years ago at a workshop, I discovered that my usual habit of arranging a vast array of pastels on a large taboret took more time and space than could be tolerated in a classroom setting, so I decided to work in charcoal on toned paper with the addition of white Conté for highlights. I resolved to leave my pastels packed and out of everyone's way.

Before long, however, I found the rich skin tones of the models too evocative to leave out. I eventually slipped over to where I had stored my supplies and retrieved a stick or two of my favorite pastel colors. I worked economically with only a handful of pastels and some charcoal. The initial results delighted me. Within a few days, I had worked out a system that resulted in lovely tonal studies which gave the impression of full-color works.

Making Colorful Tonal Studies

To try this yourself, begin with a sheet of charcoal paper in a middle tone. Don't be put off by how dark the midtone papers seem at first. As you push the value range, the paper will appear much lighter.

Tone the paper by scraping willow charcoal with a single-edged razor blade to distribute a fine layer of dust, then spread the dust with a soft chamois cloth (the more blackened with charcoal, the better). Don't spray the paper with fixative at this stage.

Begin the drawing with hard and soft vine charcoal, a charcoal pencil, a chamois cloth and a kneaded eraser. Draw in a loose and painterly way with the side of a soft vine-charcoal stick. The kneaded eraser does a great job of removing all traces of charcoal, including the initial toning. The clean color of the paper will shine brightly in comparison to the toned areas.

By this point, you will have a nearly completed study. You can finish by simply describing the highlights with a light pastel, or you can apply color. If you choose to add color, pick two or three soft pastels in three values: dark, midtone and light.

Maintaining broad strokes and light pressure, take the darkest color and drag the broad edge over the shadow areas of the charcoal study. Rich, saturated middle values are an excellent choice for charging half-tones with color. Finally, describe the light areas by filling them with colorful lights, using the same broad strokes and light pressure as before. This imparts a grainy and atmospheric infusion of color.

To finish, sharpen the pastels and selectively apply them in linear strokes with heavy pressure to push the darks and punch up the highlights.

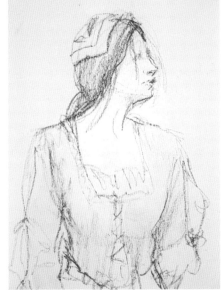

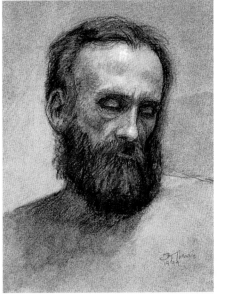

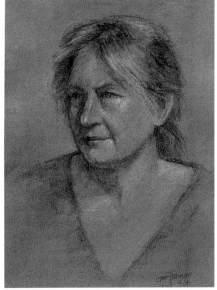

Single Color

I executed this eight-minute study from life with a single Conté crayon.

Eight-Minute Study of Costumed Figure
Conté crayon on bond paper

Two Color

Though I varied the color of the paper, both drawings rely on exclusively black and white drawing tools.

Head Study of Bearded Model
Charcoal and Conté on gray Canson Mi-Teintes

45-Minute Study of a Model
Charcoal and chalk on tinted Canson paper

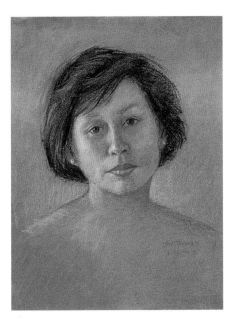

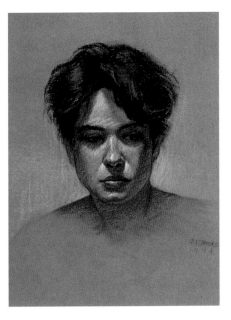

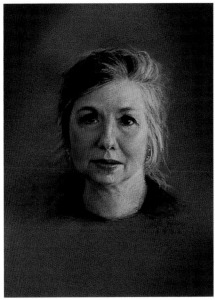

Three Colors

The three-color portraits (a technique favored by the Old Masters) include black, white and—in this case—sanguine Conté. The commissioned drawing is smoother, but I left my strokes more expressive and loose in the study.

Tricolor Study of Donna
Charcoal, Conté and Chalk on tinted Canson paper

Female Head Study Looking Down
Limited palette pastel on tinted Canson paper

Six Colors

Though six colors may seem like a lot for a drawing, it's really considered a limited palette. Nevertheless, at this point, many artists would consider this a painting rather than a drawing.

The Print Dealer
Limited palette pastel on gray Canson Mi-Teintes

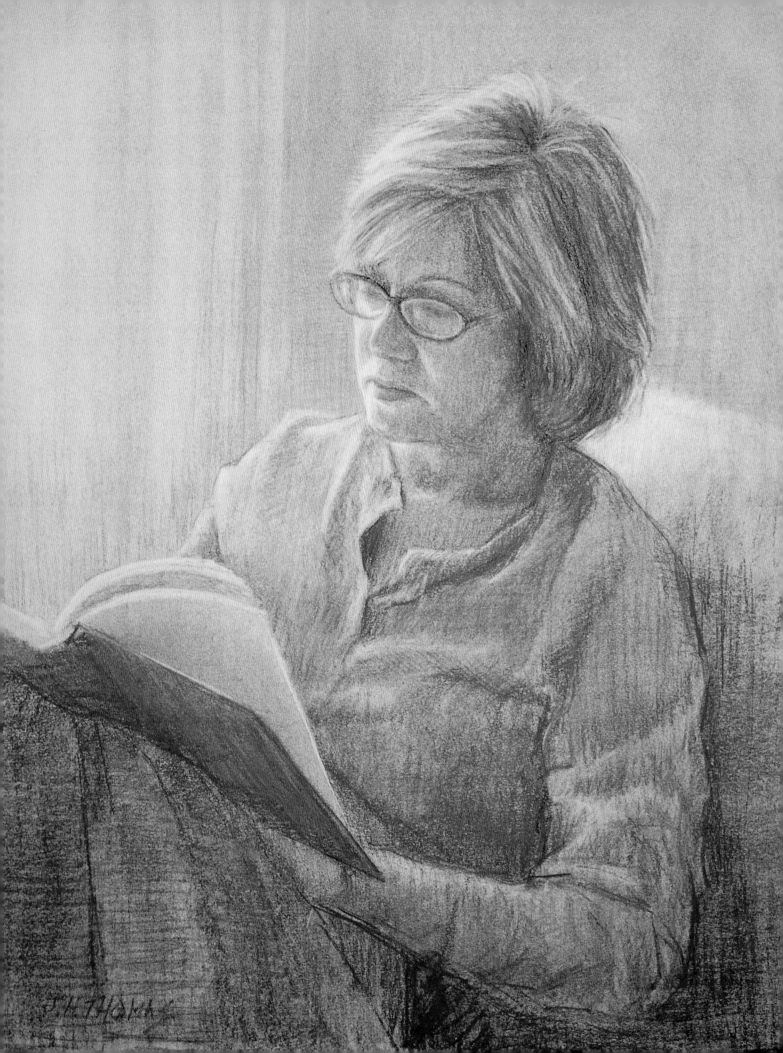

Practicing Your Art

To some, following specific step-by-step instructions may seem an unimaginative and overly technical endeavor. For others, such instruction will serve as a road map for the challenging journey ahead, providing a few of the tools needed on an emotional and intellectual quest.

Through study, hard work and practice, the disciplined artist will develop swift, confident skills and a powerful ability to express their own artistic vision. Through study and practice, you begin to internalize the formal elements and principles of art. Ultimately, after you have mastered the elements and principles, your abilities will become intuitive.

Mary Reading
Chalk on Canson Mi-Teintes paper

Charcoal Study of Warren

MATERIALS

Bond paper

Soft vine charcoal

Compressed charcoal stick

Soft graphite pencil

Charcoal pencil, medium and soft

Kneaded eraser

Matte spray fixative

Measuring is important in all drawing, but it's absolutely imperative in portraiture. There's more room for artistic license with landscapes or still lifes, but if a portrait is off, you know it instantly. When attempting a portrait, it's crucial to go after anatomy and perspective to capture the likeness. You do this by observing, measuring, correcting, redrawing, more measuring and more correcting. It takes some knowledge, a lot of observation and years of practice. This head study will give you the opportunity to develop basic measuring and placement skills.

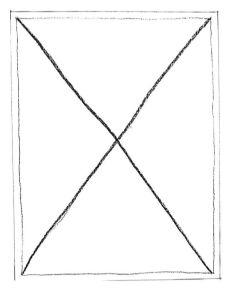

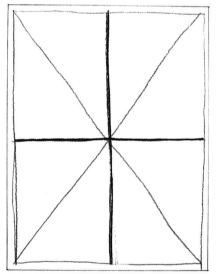

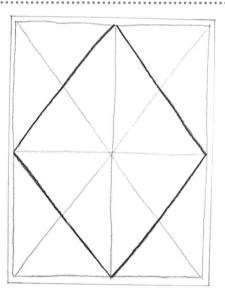

1 Establish the Perimeter
Using soft vine charcoal, create a perimeter for the picture. Anything outside of this perimeter will be lost when framing, so leave it out of consideration while planning the composition. Begin a grid by drawing lines from corner to corner to form an "X".

2 Place the Centerlines
Place centerlines, forming a cross to divide the surface into quadrants.

3 Draw a Diamond
Add a diamond to determine the center of each quadrant.

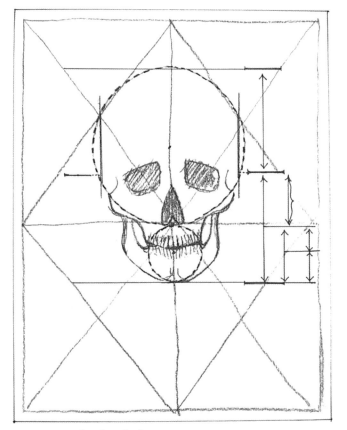

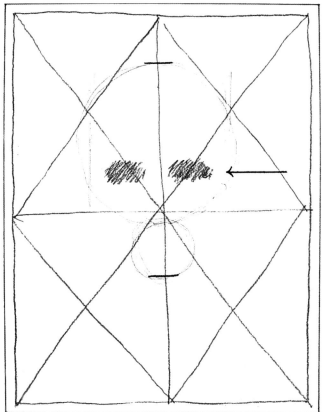

Consider the Skull

4 Consider the structure of the skull before beginning the frontal head study. You don't need to draw the skull on your paper as I have done here, but think about it as you approach this portrait. Think of the skull as consisting of two circles. The large circle's circumference, determined by the distance between the top of the head and the bottom of the nose, represents the cranium. The small circle's circumference, determined by the distance between the bottom of the nose and the chin, represents the muzzle. The jawline or mandible connects the two circles.

Even though different standards are used to determine the exact proportions of the head, the skull is most simply divided into halves, so indicate the placement of the features accordingly: eyes approximately halfway between the top of the head and the bottom of the chin, nose halfway between the eyes and the chin, mouth halfway between the nose and the chin.

Place the Head and Mass In the Eye Shapes

5 In this study, the subject will be centered and facing us. Determine the placement of the head along the centerline with just two marks representing the top of the head and the bottom of the chin. A typical placement puts the top of the head at a forehead's distance from the edge of the frame and leaves plenty of room (approximately half the height of the head) for the neck and clavicle, providing a proper pedestal for the head. Use soft vine charcoal to place the eye sockets halfway between the top of the head and the bottom of the chin, keeping an eye's distance between them.

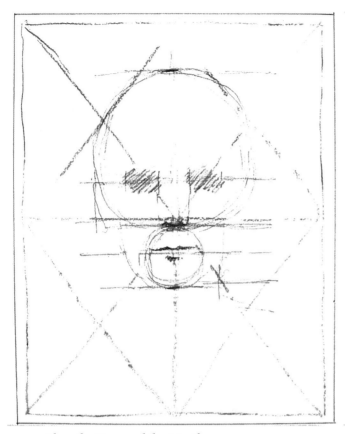

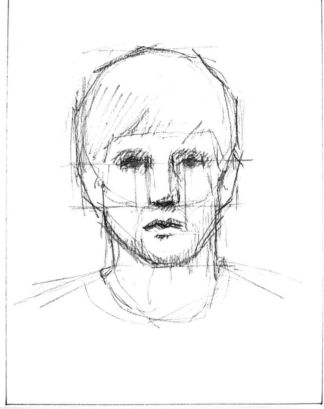

Place the Nose and the Mouth

6 Use a soft graphite pencil and a light touch for this step. Place the features by indicating planes. Avoid drawing outlines or using symbols. Instead, look for the underplanes of the nose and lips, then make economic, shaded marks as a first statement. The nose and mouth are centered on the axis, with the bottom of the nose placed approximately halfway between the eyes and the chin. Place the mouth about halfway between the nose and chin.

Develop the Likeness

7 Remove the grid with a kneaded eraser. Begin searching for the outside contours of the head by indicating the jawline and placing the ears. The ear hole is always just behind the point where the jaw attaches to the cranium. It's generally said that the ears are placed between the halfway mark for the eyes and the mark for the bottom of the nose, though ear size actually varies from person to person. In this case, the ears hold to the standard.

Squint your eyes and smudge in the darkest values. Drop plumb lines to find the width of the lower part of the nose, which is typically equal to the width of an eye. Use additional plumb lines to develop the eyes and mouth. The inside of the irises, according to standard measuring, line up with the corners of the mouth. Maintain a light touch and loose marks to hatch in the shape of the hair and the shadows.

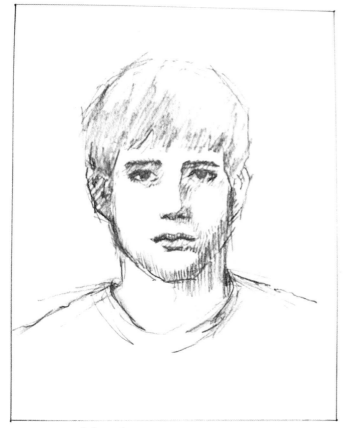

8 Extend the Value Range

Use a kneaded eraser to clean up the construction marks and to lift out the whites of the eyes. Describe the eyebrows and selected details with short, broken strokes using a charcoal pencil. Use hatch marks like these across the form to avoid outlining features. Use a medium charcoal pencil to extend the value range and to strengthen the elements of the drawing that you are confident will remain.

9 Finish the Drawing

Continue to lift out highlights with a kneaded eraser. Use a soft charcoal pencil and heavy pressure to make a few bold marks and to strengthen a few of the edges. A discretionary use of line will impart a sense of detail and finish. Spray with matte spray fixative.

Charcoal Portrait of Sarah

MATERIALS

Canson paper in a bisque tone

Assorted vine or willow charcoal

Single-edged razor blade

Small filbert brush

Easel

Soft charcoal pencil

Chamois cloth

Kneaded eraser

Drawing board

Extra paper for padding

Bulldog clamps

Supersized rubber band

Matte spray fixative

Viewfinder

Charcoal is typically assigned to beginners, but I still find it a difficult medium. I'm actually most swift and at ease when painting head studies in oil now! There are many valid procedures for attempting a charcoal portrait, and it's a good idea to try different approaches to find the one that suits you best (and then try something else, to expand your abilities). I have developed a system of working with toned paper that lends itself to a painterly approach, with satisfactory results.

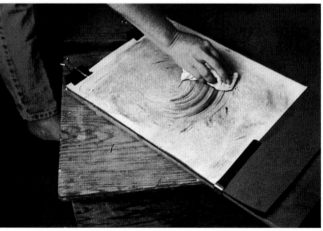

1 Tone the Paper

You can model form much more quickly and effectively on toned paper. If you tone your paper to a midtone, you can add dark areas with charcoal or lighten areas with a kneaded eraser. Canson paper has a textured side and a smooth side; turn the paper to the smooth side. Hold the compressed charcoal stick over the paper's surface, then scrape along the charcoal stick with a single-edged razor blade, sprinkling the paper with dust. Tone with chamois cloth, using light pressure and a circular motion. Achieving the desired tone may take additional applications. Secure the toned paper to the drawing board with Bulldog clamps at the top and a supersized rubber band at the bottom. Make sure to have quarter-inch (6mm) of padding such as a pad of newsprint between the board and the paper to provide the necessary "give."

Prepare and secure the paper before the model arrives. Tilt the easel forward so dust will fall away from the drawing. Angle your easel so you can see the model and your drawing simultaneously.

2 Make a Grid

Using soft vine charcoal, mark a half-inch (12mm) perimeter from the edges of your paper. (This perimeter will be lost during the matting and framing, so don't include it in plans for the composition.) Start the grid with an "X," then add centerlines to form a cross, and end with diagonals to create a diamond as shown.

MODEL COMFORT

Ensure the model's comfort by providing a comfortable chair, footrest, cushions, water and a sound system with a nice selection of music. Use a model stand to elevate the subject to eye level, as it is preferable to stand while you're working. Try placing a freestanding mirror behind you at such an angle that the model can see the drawing reflected, thus following its progress. Just make sure it is several feet behind you so you won't trip over it as you step back to view the drawing.

3 Plan the Composition

Plan the composition and set the pose. When setting the pose, try emphasizing gesture by having the model's head turn in a different direction than her shoulders. After deciding on the pose, use a viewfinder to determine the composition. (Make a viewfinder with two black mat corners and a couple of large paper clips.) Stand back from the easel while holding the viewfinder at arm's length. Close one eye to look at the paper through the opening, and begin adjusting the two corners until the aperture is of equal proportion to the paper's size. Secure the viewfinder with paper clips.

Always hold the viewfinder at arm's length while looking at the subject. Adjust what you see by stepping forward or back.

Determine your mark (where to stand) and place the easel so you always see the same composition through the viewfinder while standing on your mark.

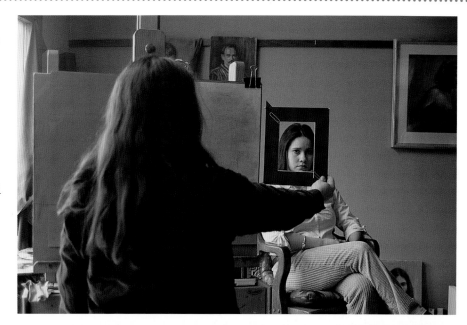

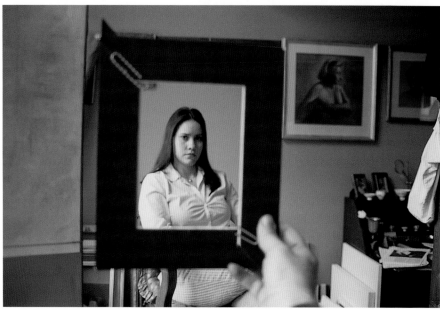

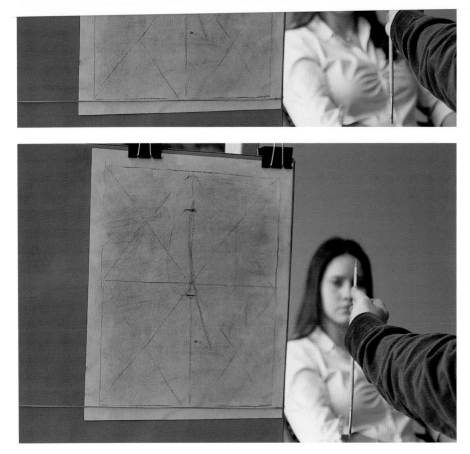

steady, slide your thumb down, and mark the next point with your fingernail (in this case, the inner corner of the eye). Rotate your hand, maintaining arm's length, and look for horizontal measurements that equal your vertical measurements. Begin placing the feature lines.

It's usually best to work from the inside out. Determine the placement of the head along the centerline with just two marks of soft vine charcoal: the top of the head and the bottom of the chin. Avoid drawing an egg or oval shape to represent the head. Place the chin just below center, the mouth at center and the top of the head a forehead's distance or more from the perimeter.

Now, drop a sweeping line from the top center of the head to the sternum to make note of the subject's gesture.

Mark the placement of the eyes, nose and mouth. Remember to think in halves: The eyes are halfway between top of head and bottom of the chin, the nose is halfway between the eyes and the chin, and the mouth is halfway between the nose and the chin.

5 Mass In the Features

Using the side of a pencil or brush, sight-size the angles from the outside edges of the nostrils to the outside edges of the eyes. Sketch these angles with your vine charcoal, matching them to reality. This creates a "V" to contain the eyes and nose. Using soft vine charcoal, mass in the eye sockets and nose shadow. Take more measurements, then mass in the shadowed planes of the mouth, at center, under the "V."

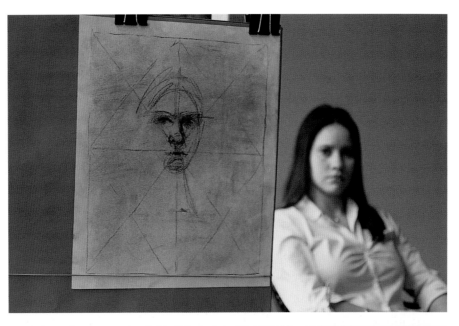

6 Establish Value Gradation

Squint at the subject to simplify the values. Use broad strokes of soft vine charcoal to mass in the hair and the darkest darks. Use a light hand to tentatively indicate the head's outline. Shape a kneaded eraser to lift light areas, leaving the toned paper as the middle value.

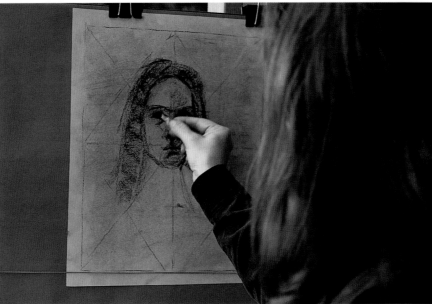

7 Place the Neckline

Measure, then indicate the neckline with vine charcoal. Consider the collar or neckline as a base or

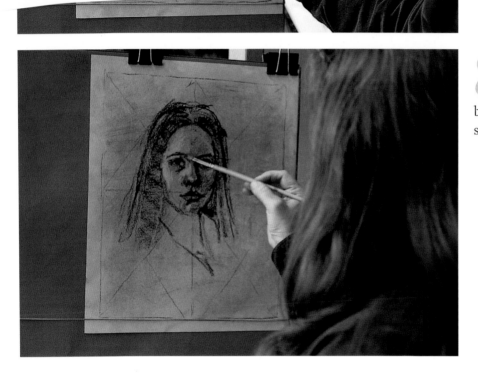

8 Develop Detail

Move the tone and develop a bit of detail within the dark shapes by pushing and lifting value with a small filbert bristle brush.

Mass In Light Areas

10 To mass in the light areas, like the collar, lift charcoal with a kneaded eraser.

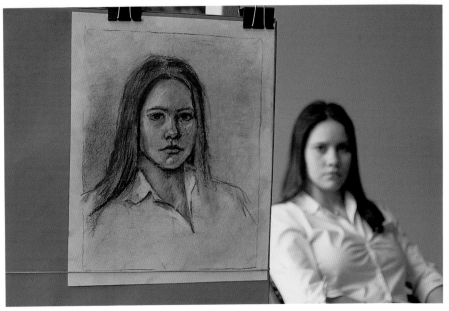

Develop the Likeness

11 Using all of the techniques as previously described (massing with charcoal, moving tone with a brush or cloth, lifting tone with a kneaded eraser), continue to develop the likeness through measurement, correction and by pushing the values and edges.

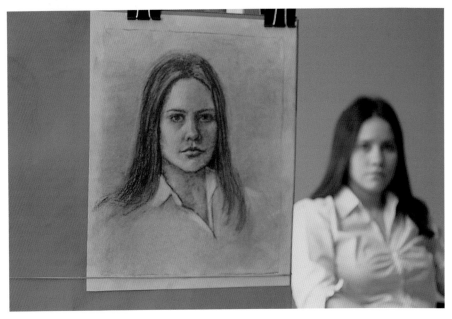

13 **Move Tone at the Edges**
Address the edges, varying the lost (soft) and found (hard). Create velvety, dark passages with a bristle brush.

Add Final Details

14 Finish by lifting out the highlights with a kneaded eraser and strengthening the darks with a charcoal pencil. Add selective and final details with the charcoal pencil using very firm pressure.

Apply Fixative

15 Sign and date the completed portrait, then take it outside or to a spray booth to apply fixative. After testing the spray on another surface, hold the can about 20 inches (51cm) from the artwork and spray in sweeping strokes, from side to side. It's best to apply several light coats, allowing each to dry thoroughly before applying the next.

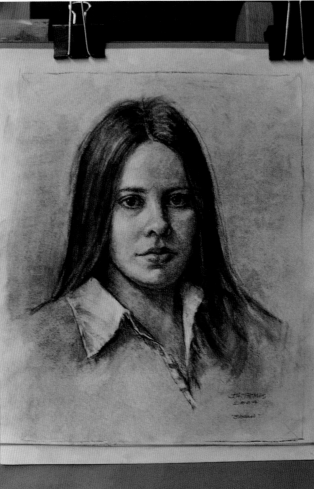

The Finished Portrait (opposite) This is a very honest demonstration of a challenging task. Though I have checks and balances built into my system of measurement and placement, in the end it seems that I push, pull and tweak the final result into being.

Sarah
Charcoal on Canson paper in bisque tone

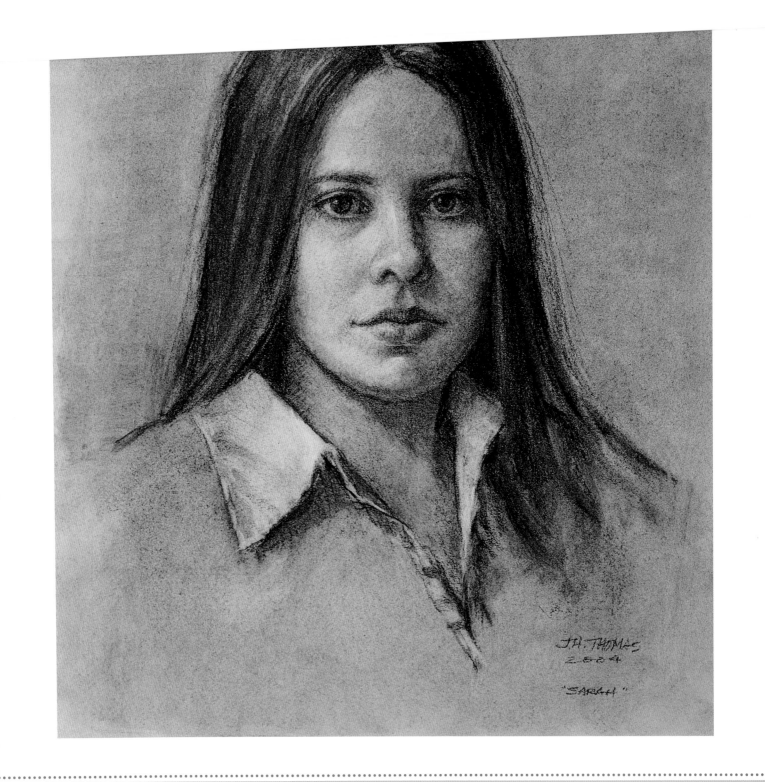

Graphite Pencil Drawing of Kimberly

MATERIALS

Mechanical pencil

Graphite pencils
(2B, 6B)

Stonehenge paper in
warm white

Straightedge

Bulldog clamps

Rubber band

Kneaded eraser

Viewfinder

There are a lot of decisions to make when creating a portrait. Kimberly, my model for this demonstration, brought a variety of attire and accessories with her. We fell into a casual conversation, with me asking a lot of questions as we tried different clothes, poses and lighting. She is a married schoolteacher and a mother. As she talked about her parents, I learned that her paternal grandfather immigrated to America from Greece. This romantic notion made her compelling eyes seem even more exotic to me—a quality I wanted to come through in the final drawing.

Prepare the Paper

On the day that Kimberly was scheduled to sit for me, I prepared my paper by measuring, then tearing the paper against a straightedge to simulate deckled edges. I decided to use graphite pencil on warm white Stonehenge paper.

The model stand is on heavy rolling casters so it can be adjusted without having the model move her chair. I walked around Kimberly to study her from different angles. I finally decided to add a head scarf.

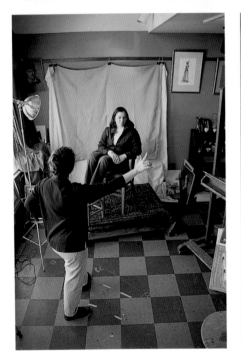
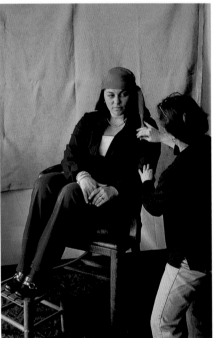

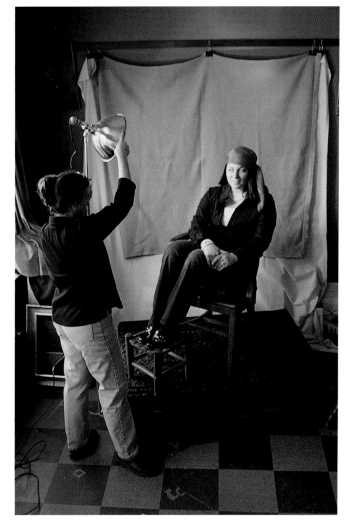

3 Arrange Lighting and Pose

Because it was a cloudy day, I supplemented the natural north light with a lamp and reflector for more dramatic lighting. I decided to use a three-quarter pose, lit from my left. It's a pose I'm fond of and one that works well here.

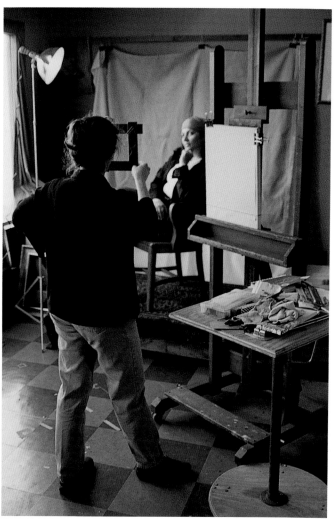

4 Make Adjustments

As I adjusted the lighting, the model rested her chin on her hand in this expressive gesture. I asked her to hold it. Her French cuff, lapels and camisole create interesting shapes. With her arm up, the pose has more depth and interest. Look for natural gestures as the model moves or waits for you. As with Kimberly's gesture here, these details can bring a great deal of life to your composition.

A viewfinder (see page 66) is a useful aid for visualizing your compositions. It eliminates the outside distractions so you can review the overall arrangement. Study the pose through a viewfinder to determine placement on the page.

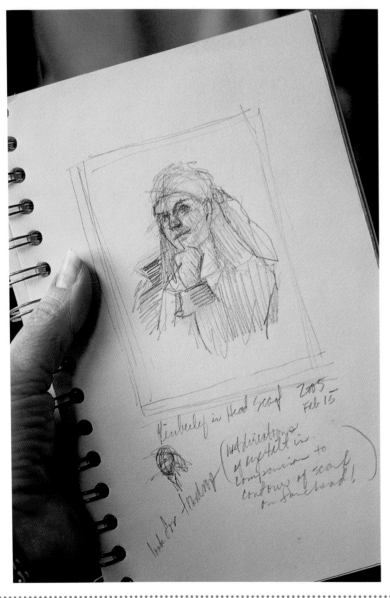

and the bottom of the chin, then look for the teardrop shape of the skull to place within those perimeters. Next, lightly sketch the axis of the head and the arc through the middle of the face. Add the division lines to the face to help place features and to determine the perspective. Look for points of intersection, like where the shoulder intersects the cheek.

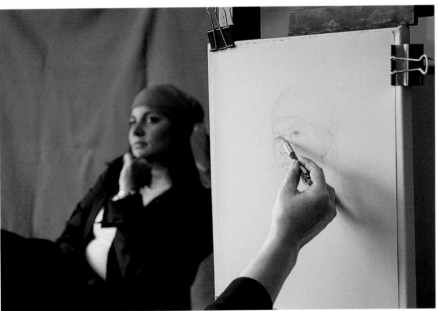

7 Search for the Features

Maintaining a light pressure, you can begin the portrait in an exploratory, free way. Look at the subject more than the paper. Keep the point of the pencil in contact with the surface while searching for the model's form with faint, sweeping lines. Don't erase at this point; the faint lines will eventually be obscured as darker marks are correctly placed. Any remaining faint lines will give the finished drawing an artistic quality.

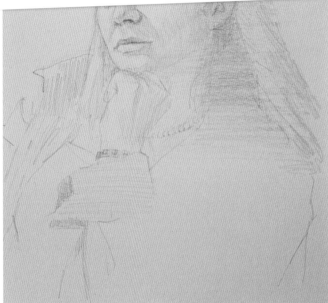

8 **Work Outward From the Nose**
Develop the face by placing the "ball" of the end of the nose, and then draw the other shapes that radiate from the nose.

9 **Create a Shape Map**
Create a shape map by determining the shapes and how they fit together, like a puzzle. Locate all geometric shapes, such as the triangular shapes in the scarf and the hair. Also note the geometric shapes formed by the hand, arm and clothing.

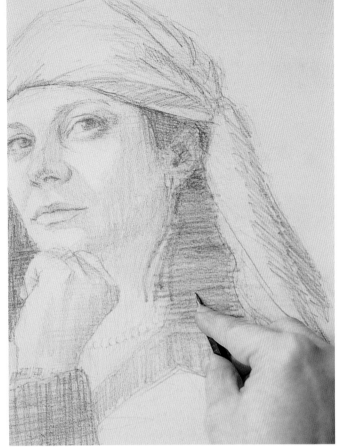

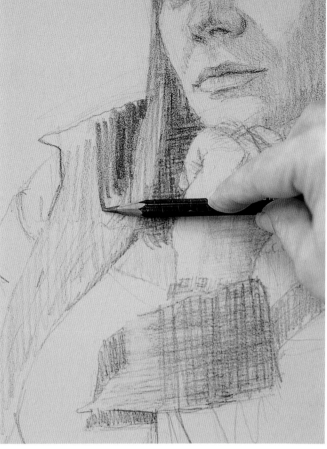

10 Add Tone With Hatch Marks

When you're confident with the first statement, switch to a softer pencil, such as a 2B, for a darker mark. Place the pencil on its side for broad strokes, then fill in the shapes with rapid, long hatch marks, working across the form. Start with the hair shapes around the ear and work down to the lapel and across to the cuff. Nothing is being outlined; the goal is to fill in the dark values, connecting the hair, lapel and cuff into one dark shape. Change the stroke's direction to describe different forms. The marks go up and down, and back and forth to "weave" an interesting pattern of marks. Create gradation by varying the pressure on your pencil.

11 Establish the Darkest Darks

Use a 6B pencil, or darker, to seek out the darkest values and state them using the same hatching technique. Restate the darkest darks of the facial features with firm pressure and linear marks.

This is a good time to evaluate the values. Here, I decided that nothing should be *lighter* than the paper of the background or the highlights on the face and that nothing should be *darker* than the darkest darks of the eyes. This establishes the value range of the drawing.

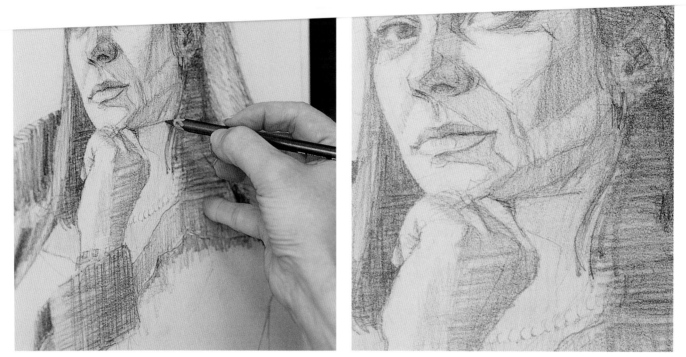

12 Construct the Planes

Restate the head. Seek the angles while outlining the planes in order to clearly define the cheekbones, jawline, and create shadows. Piece together the portrait as you would a jigsaw puzzle, considering how every part relates to its neighbors as well as the whole. Constructing the planes this way will reveal mistakes while establishing form.

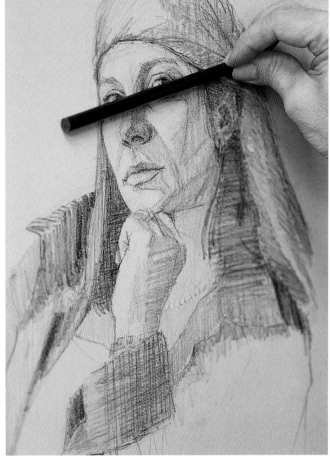

13 Check Angles and Distances

Test the placement of the features by measuring all the distances and angles of your drawing, then compare those against the same measurements on the model. Make corrections as necessary.

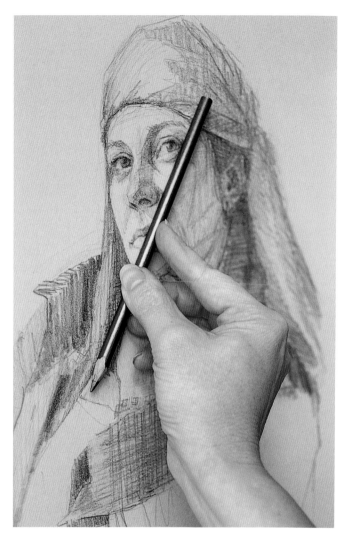

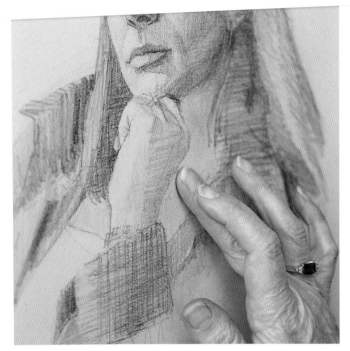

14 **Blend the Graphite**
Wash and dry your hands, then use a clean, dry finger to apply even pressure while sweeping back and forth across the entire drawing. Typically, one should avoid touching the paper, as the oils from the body can damage the surface. But with lots of graphite in place, you may sparingly use this finishing technique to distribute the graphite, create value transitions and tone the entire portrait while preserving the integrity of the marks.

15 **Lift Tone for Highlights**
Look for the highlights on the model. Lift the highlights with the tip of a kneaded eraser.

MODEL ETIQUETTE

I like to place a mirror behind me so the subject can see what I'm doing. It helps the subject stay engaged and interested in the project, and helps keep her or him from tiring.

The Finished Portrait (opposite)
Working with graphite on a larger portrait is not in keeping with my usual mode of operation. This was a good opportunity to practice hatching and other linear techniques. I really like the illustrative quality of this portrait drawing. It conveys Kimberly's sassy attitude and light heart.

Kimberly
Graphite on Stonehenge paper

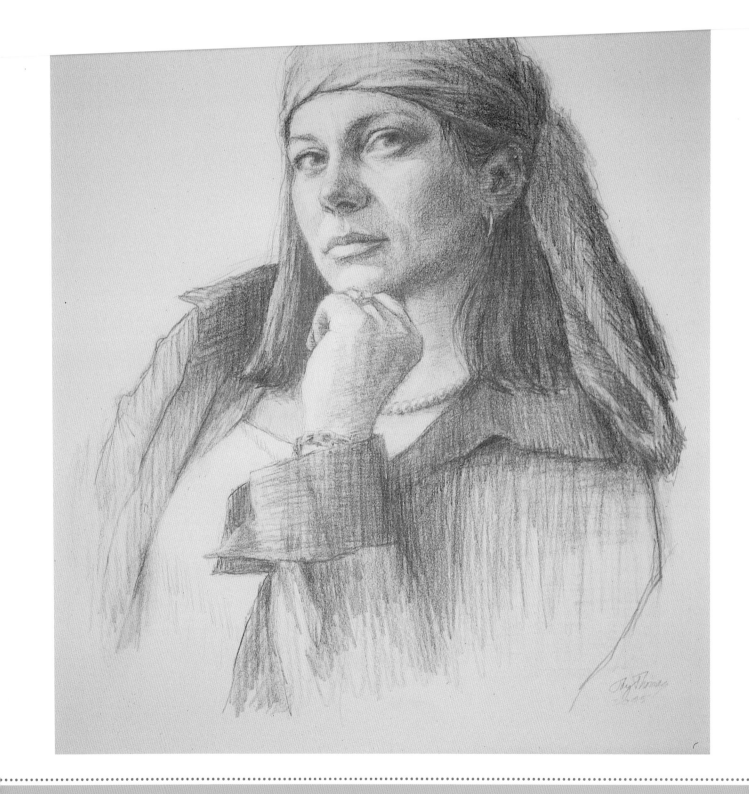

MATERIALS

Canson paper in a bisque tone

Assorted vine charcoal

Charcoal pencils (medium and soft)

Chamois cloth

Kneaded eraser

Easel

Drawing board

Extra paper for padding

Bulldog clamps

Supersized rubber band

Matte spray fixative

Bristle filbert brush

Single-edged razor blade

Bryan and his wife are both patrons and close friends of mine. After graciously agreeing to pose for me, Bryan came to my studio. The day was overcast, making the north light dimmer and cooler than usual. After a brief discussion about rescheduling the sitting for a brighter day, we decided to forge ahead.

The lighting was the first difficulty, but I made many other mistakes. None of these, however, defied correction. Though it may be a struggle, there are many mistakes you can correct in order to make a successful portrait.

Some portraits emit a charm or an artistic quality despite failing to capture a true likeness; others are obviously rendered with technical finesse but are lacking in aesthetic appeal. Aim to create portraits that are both convincing and pleasing. Work toward achieving accuracy, technical virtuosity and artistic merit.

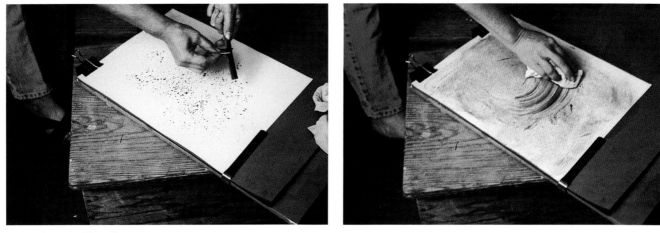

1 Prepare Your Paper

Secure your paper to a drawing board with padding underneath using Bulldog clamps and a supersized rubber band. Tone the smooth side of the Canson paper by scraping soft vine charcoal onto the surface with a single-edged razor blade. Work it into the paper with a chamois cloth. It may take a few applications to achieve the desired tone. When you're satisfied, prop up the board or set it on an easel in a position that allows you to see both the drawing and your model.

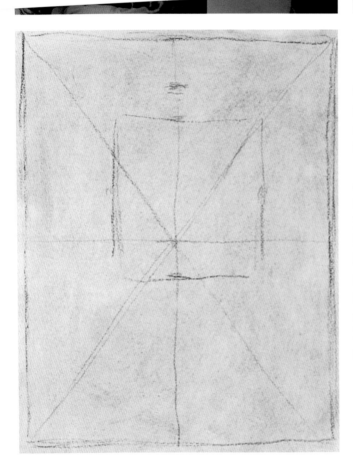

2 Determine the Arrangement

Using soft vine charcoal, create a perimeter to allow for framing, then divide the paper corner to corner, through the middle and finally in a diamond to determine the centers of the quadrants.

When determining the placement of a head study, a good rule of thumb is to keep at least a forehead's height between the top of the head and the inside edge of the mat or frame. It also helps to think of the head as a box or square. Placing the center of the box above center, leave room for the neck and collar to provide a pedestal for the head, in order to create a bust as seen in classic sculpture.

 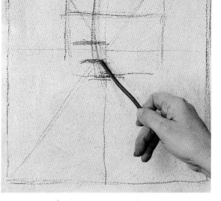 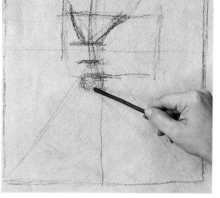

3 Place the Face

Place the first indications of the face using your vine charcoal. Although it's often desirable to center the head on the paper, in this case a bit of space appears in front of the face, by placing the box to the right of center. A curved line follows the center axis of the face.

4 Mark Feature Locations

Using your vine charcoal, place a horizontal line between the top of the head and the bottom of the chin to indicate placement the eyes. Next, place a mark between the eyes and the chin to indicate the nose. Then place a mark between the nose and the bottom of the chin to indicate the mouth.

5 Determine Angles

Lay a pencil against each corner of the eye and down to the outside edges of the nose to determine the angles. Those angles form a "V" that will contain the eyes and nose. Follow standard measurements in the very beginning, and then look for the characteristics that are unique to the model. In this case, Bryan has a generous jawline, so the chin is described as a ball placed just under the bottom of the box.

6 Mass In the First Shapes
Search for the bridge of the nose, cheekbones, and eye sockets and see how these elements relate to and define one another. Also look for landmark shapes and values, such as the ball of the nose and the chin, the shape of the eyelids, the corners of the mouth and the form of the forehead. Now make a quick statement of the eye sockets, eyes, and the bottom plane and bridge of the nose. Begin to develop the mouth.

7 Use Plumb Lines to Line Up the Features
With the vine charcoal, drop a plumb line from the inside corner of the eye to the outside of the nostrils to the corner of the mouth. Look for how these features line up in relationship to one another and in order to determine proper placement.

A COMMON MISTAKE

Showing too much of the far side of the head is a common mistake when drawing the three-quarter pose. Continuously measure and correct to ensure that this half of the face stays narrow enough.

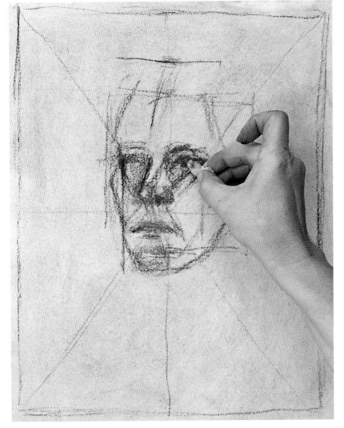

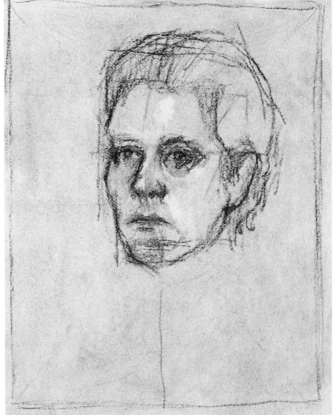

8 **Lift Tone for Value Gradation**
After sketching the shape of the jaw and chin, establish the form by introducing more value gradation. Lift out the lighter planes with a kneaded eraser. Remove construction marks with the eraser and by rubbing with the chamois cloth.

At this point, step back and compare the portrait to the model. Take your time, study the model carefully and scrutinize your work objectively.

9 **Indicate Shapes and Strengthen Dark Values**
Indicate the hair, the shape of the ear and the eyes, and strengthen the dark shapes with a soft charcoal pencil.

10 Lift Highlights and Reassess

Lifting out a few of the highlights at this point will help you find your bearings and lead the way to more questions: Where is the flesh of the cheek? Where does the bone catch the light? Are the eye sockets too high or too low? Is the mouth the correct width and placement? As you study the model, imagine an overlay of plumb lines, angles and geometric shapes to help you sort out the visual information. Avoid finishing any one feature before confirming the placement and bone structure. Ask additional questions: Does the nose protrude enough or too much? Is the mouth too high or too low? Are the eyes the appropriate distance apart?

11 Restate and Strengthen the Form

Restate the image in charcoal, then address the edges by moving the charcoal with a bristle filbert brush. When the model takes a break, it's time to scrutinize the piece with an objective eye and look for ways to correct the drawing while strengthening the form. This can be a difficult stage, because the portrait begins to take on a life of its own and can intimidate its maker. In order to capture a likeness, it's crucial to remain objective. Attempt to make accurate corrections as you begin, again, to redraw.

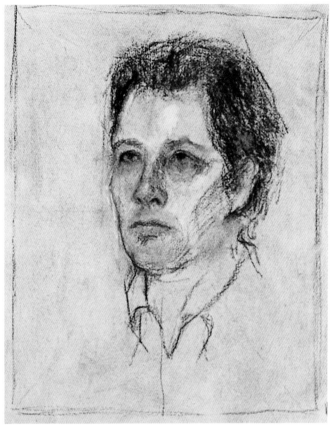

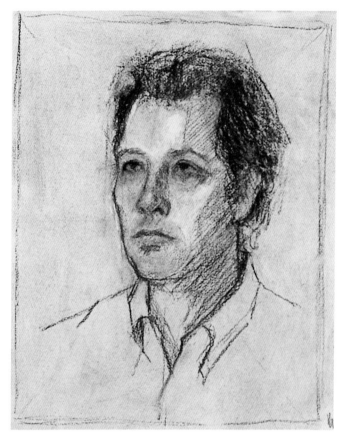

12 Apply Dark Tone

Block in the dark shape of the hair with a soft charcoal pencil. Measure carefully, then indicate the neck and collar. Block in the shadows on the neck and face. Push the charcoal with a brush to simplify the tone.

14 Analyze Your Drawing

Analyze the drawing from each angle: aesthetic, technical and anatomical.

It takes skill and courage to make corrections to an existing work of art, especially if you're seeking something elusively expressive. Knowing how to bring the portrait to a higher level without overworking it takes years of working from life and a lot of failures. If you feel intimidated by the good things that are happening in the portrait and are afraid of ruining everything, just remember: if you did it once, you can do it again. Get ready for the final redraw and some very exciting changes.

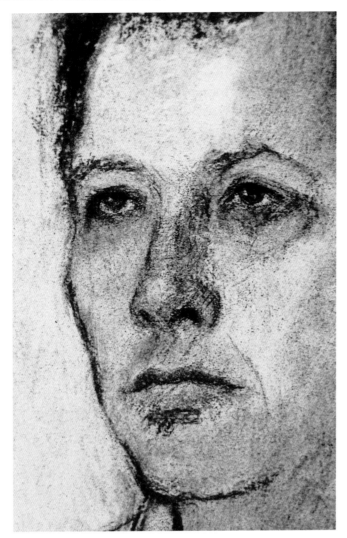

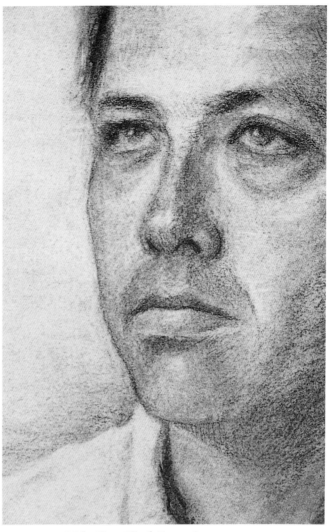

15 **Identify Any Mistakes**
Here, you can see evidence of a common mistake with the three-quarter pose: too much of the far side of the face is showing and needs to be narrowed. This means the eye on our left must be moved, and also the mouth. Bryan has blue eyes, which will be difficult to convey in charcoal, so much care with the detail will be required as the values of the eyes are corrected. The nose is too broad, so the bridge must be redrawn and refined. The upper lip should be smaller and the lower lip more full. All light of the light/dark pattern must be restated. All of the transition tones should be subtler. Redraw to correct your mistakes.

16 **Make Your Final Corrections**
Make the final, subtle corrections by removing charcoal with a kneaded eraser and redrawing with a medium charcoal pencil. Shape the kneaded eraser into a very sharp point to work the details, paying special attention to the eyes. Keep in mind that the eyelid acts as a hood that casts a shadow over the eyeball. Continue using light pressure and a kneaded eraser to lift the light areas of the cheekbone, lips, brow, bridge of nose, etc. Finally, find the darkest lines and state them with hard pressure and a medium charcoal pencil.

When detailing the face, avoid stylizing or standardizing. Look for the particulars of the eyebrows, for example, then draw them realistically, without resorting to a symbolic or stylized brow. The goal is to capture the subject's unique likeness and presence, while revealing something of the artist, through a competent head study.

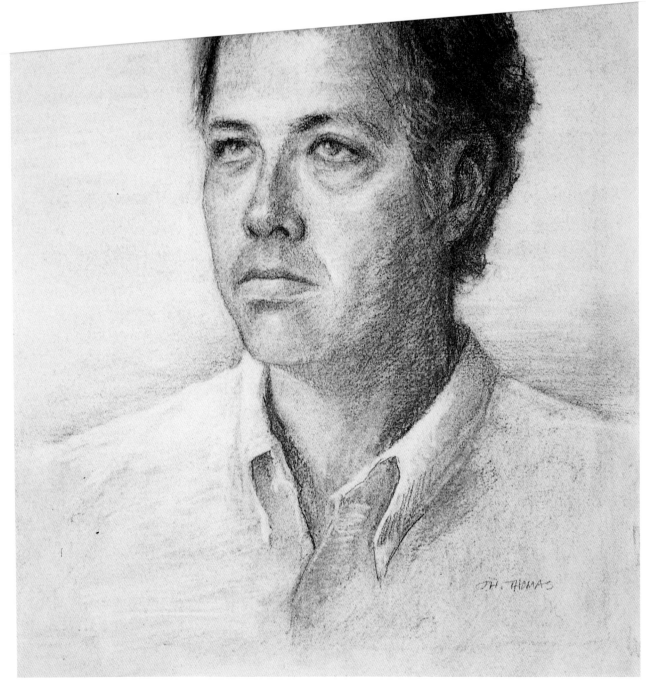

The Finished Portrait

After struggling with it, I'm now quite pleased with this appealing and somewhat eccentric portrait of my friend.

Bryan
Charcoal on Canson paper

Portrait of Mary in Sanguine

MATERIALS

Assorted charcoal pencils

Sketchbook paper

Soft vine charcoal

Sanguine and white or light gray chalk

Extra paper for padding

Chamois cloth

Kneaded eraser

Canson Mi-Teintes paper

Bulldog clamps

Matte spray fixative

Supersized rubber band

Drawing board

Easel

Mary lives in my community and is one of my favorite clients. Along with commissioned work, she has a nice collection of my head studies, still lifes and small plein-air landscapes. She is an avid reader and has cozy reading nooks in every room of her house. Mary can be somewhat quiet and reserved, which is how I decided to depict her in this atmospheric portrait.

Drawing people as they go about daily activities such as reading, working or sleeping is a wonderful way to explore gestures while creating portraits that are more narrative.

Here, I use the "envelope" method to compose the portrait. For more on this method, refer to page 38.

1 Make a Thumbnail Drawing

Thumbnails can speed the composition process when a pose is complicated or involves props. It's far easier to change a thumbnail, or to begin a new one, than to change a large drawing. A thumbnail with a grid and an envelope is easy to enlarge when transferring for a final drawing.

Create a grid with vine charcoal on sketchbook paper and then place the envelope of the pose on the grid. Mark the outside points of the subject's perimeter, then connect the points with straight lines to make one simple shape. When placing the lines, pretend you are stretching a string from one outside point to the next, corralling the form.

Think of the Golden Mean when placing the envelope on the grid. The intersection points of the grid create "sweet spots" that one should consider. Make sure the envelope relates to the grid's directional lines and "sweet spots" in a balanced way.

Also consider where the centerlines will dissect the subject. In this case, the plan is to have the vertical centerline run against the tip of the nose, through the middle of the mouth and chin, then down to the corner of the book. The horizontal centerline will divide this envelope into two interesting wedge shapes. Keeping the two major shapes (the book and head) to either side of center, both vertically and horizontally, creates a balanced design.

The arm and the top edge of the book cover will follow the diagonal of the grid's lower right quarter, while the diagonal at the top left will run parallel to the direction of her gaze.

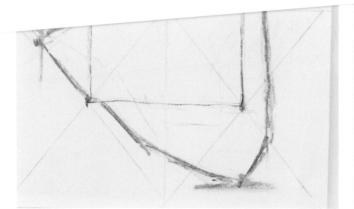

2 **Sketch Major Shapes in the Thumbnail Drawing**
Using the grid as a guide, place secondary envelopes and shapes within the whole using a charcoal pencil. Create "lead-ins" to the focal point. In this case, the neckline, far shoulder, book and arm all lead the viewer to the face. Also look for the "sweep of arches," such as the arch of the shoulders and the pages of the book. Both of these arch toward the center of interest, which is the face.

3 **Start Your Drawing**
Secure your paper to a drawing board with padding underneath using bulldog clamps and a supersized rubber band, then prop it up on your easel. Angle your easel so you can see your subject and your drawing simultaneously. Transfer the grid, then the envelope, to the larger paper using vine charcoal. For this drawing, I started with an unidentified paper that I found stored in my studio. It didn't work well, so I later switched to Canson Mi-Teintes paper.

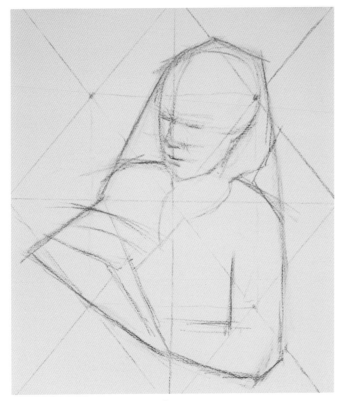

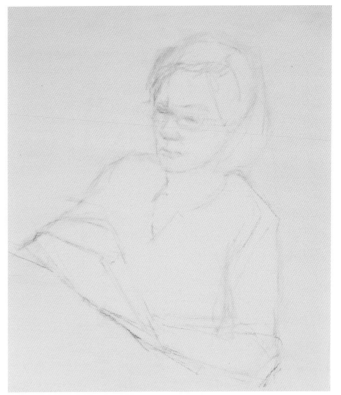

Transfer the Interior Shapes

4 As you transfer the interior shapes, search for descriptive shapes and interesting tangents, such as the teardrop shape of the skull and the intersection of the sweep of the shoulders with the jaw. Take note of pathways, such as the shirt placket leading from face to book, which also echoes the grid's diagonal from top right to bottom left.

Place the Features

5 Place a few features and other shapes. Think of the inside shapes in geometric terms. Identify the shapes and how they relate to one another as you construct the drawing, such as the triangle created by the bent arm and its relationship to the triangle of the book.

Once you are confident of the placement, erase the construction lines of the grid and envelope.

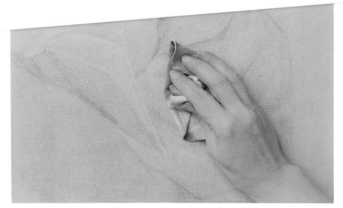

6 Develop the Form

At this point, the gesture confirms that this is a person reading. Now it's time to develop form. Use sanguine chalk on its side to mass in the darks. Then make bold sweeping strokes with a chamois cloth across the entire drawing to distribute the sanguine and tone the paper.

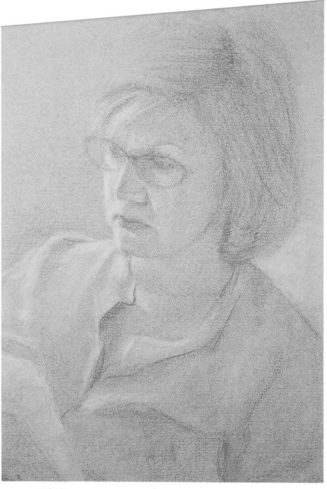

7 Lift Tone

Shape a kneaded eraser and lift out the light shapes to establish a light/dark pattern. Lift enough tone in the lightest places so the original color of the paper shows through. It will appear very light. This range of value goes a long way to filling out the form.

8 Strengthen the Light/Dark Pattern

Alternately draw with the sanguine, then lift with a kneaded eraser while selectively toning with a chamois cloth. Eventually you may add white chalk to further strengthen the lights, but use a light pressure.

9 Determine Your Measurement

Determine your module of measurement (how many heads from top to bottom, for example). Check your measurements against the model to make sure that you are not "out of drawing." (As I appear to be at this point! The head is a little too large and the facial features are compressed.)

Extend the Value Range

10 Continue to work the drawing with sanguine, a kneaded eraser, a chamois cloth and a light gray or white chalk. Extend the value range and add linear details.

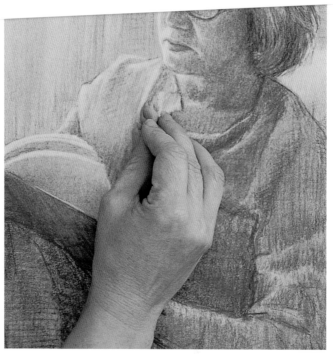

Make Corrections

11 Step back and assess your drawing, making any corrections you deem necessary. At this point, I became so frustrated fighting the paper—which was too grainy and hard-surfaced—that I switched paper entirely. (I had bought the paper years ago and labeled it simply and uninformatively as "cotton." I'm much more attentive with my inventory nowadays.) In addition to not achieving the atmosphere I wanted, I couldn't manipulate the medium to my satisfaction. So, I made the drastic decision to abandon the entire drawing. I switched to a slightly different color of Canson Mi-Teintes paper and started over. With the thumbnail and first drawing to refer to, things went quickly.

I fixed the "out of drawing" proportions, making the head smaller and decompressing the features. The Canson Mi-Teintes surface proved to be much more responsive, making additive and subtractive drawing an enjoyable experience.

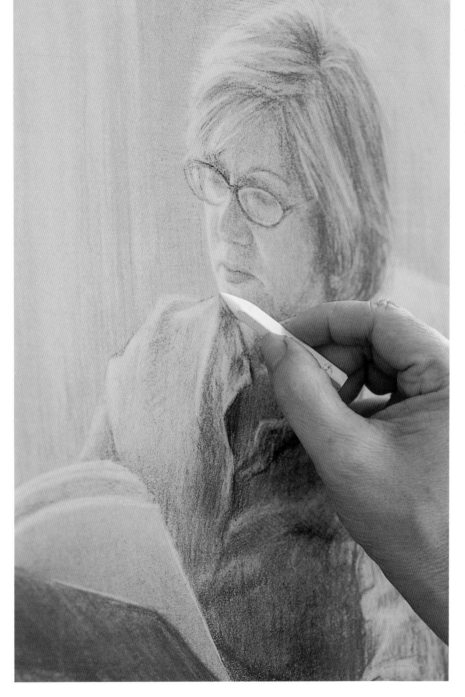

12 Add the highlights with white chalk and firm pressure. Pay careful attention to the direction and quality of the light, emphasizing it with the placement of highlights and shadows. When you have completed the portrait, spray it with fixative.

The Finished Portrait (opposite)
This drawing suggests a cozy scene. The chair was suggested by lifting tone, and the gesture suggests that Mary has her feet tucked up underneath her. Mary's glasses turned out to be a wonderful element for the portrait. Not only do they add a graphic, linear element to the painting, but they also served as a grid that I could leave in.

Mary Reading
Chalk on Canson Mi-Teintes paper

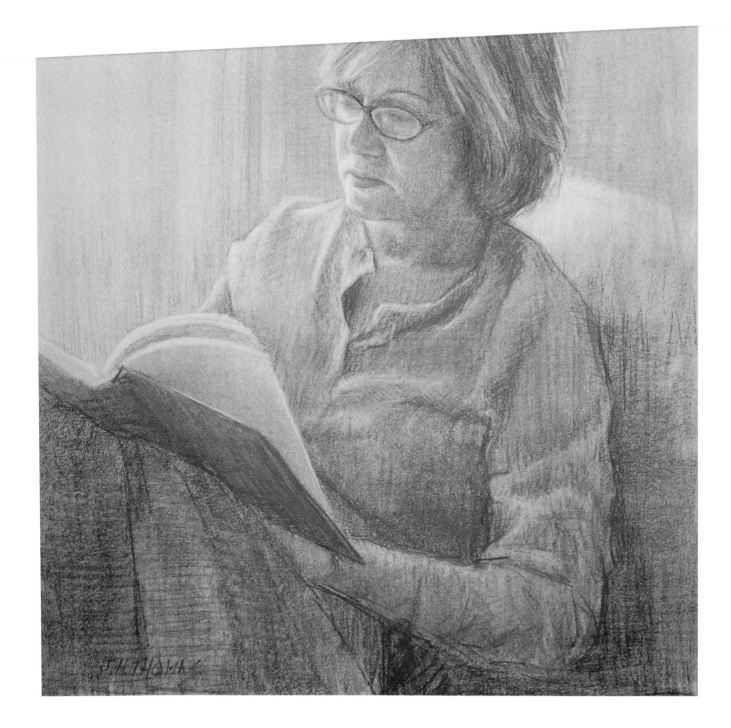

MATERIALS

Soft vine charcoal

Sepia Conté crayon

Sepia Conté pencil

Bond paper

Extra paper for padding

Drawing board

Easel

Bulldog clamps

Supersized rubber band

Kneaded eraser

I've known Linda, and her family, since she was a toddler. She has grown into a lovely, vivacious teenager. I thought it would be fun to have her model for me before she goes to college, so she set aside a weekend to pose for me and brought several outfits for my consideration. I suggested she wear this halter top because it shows off her shoulders and collar bone. I also saw an opportunity to use it as a lead-in to her face.

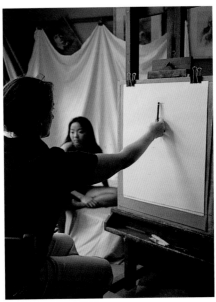

1 Secure the Paper and Establish the Pose's Height

Secure your paper to the drawing board with padding underneath using bulldog clamps and a supersized rubber band. Prop the board on the easel and position it so you can see the model and your drawing simultaneously. Establish the size of the figure by placing marks for the top of the head and the point of the toe. Using the head as a unit of measure, determine the height of the pose. (In this case, I measure with my pencil.) Divide the distance between the top of the head and toe accordingly on your paper. In this case, the pose is five heads tall.

ON YOUR MARK

So that both you and the model can easily return to your places, mark the pose and the placement of your easel with quick-release tape.

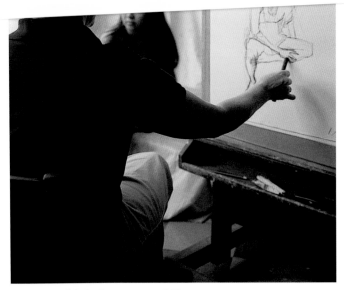

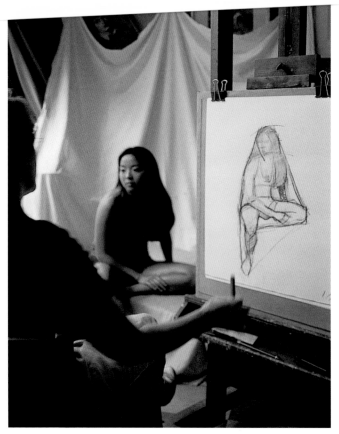

2 Establish the Pose's Width

Use the width of the head to determine the width of the pose. Then mark the outside perimeter points. Connect the points with lines to create an envelope (see page 38). Be sure to check the angles of your envelope against the model to prevent falling "out of drawing."

Using vine charcoal, sketch the limbs and other major shapes within the pose to capture the gesture. Continue using vine charcoal as you mass in the dark values.

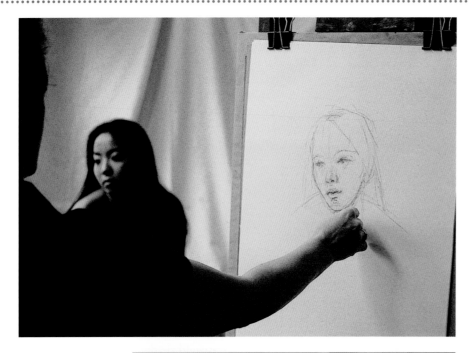

3 Establish the Head, Shoulders and Initial Features

At this point, Linda had to pose with her left leg extended to prevent it from falling asleep. So I abandoned the full figure pose and started a new head-and-shoulders portrait.

The model assumed a poignant, thoughtful gaze, looking away and down. The cascade of her hair echoes the arc of her shoulders. A length of hair sweeps in at the bust line, just under the halter's neck opening, and creates an important pathway up to the face. Including all of those elements in the composition indicates a height measurement of two and a half heads.

Using vine charcoal, mark the envelope of the pose. Then sketch lines between the outside points to establish the envelope of the pose. Sketch the shape of the head and place the features. You can see from my drawing that I have very faint centerlines, but no other grid.

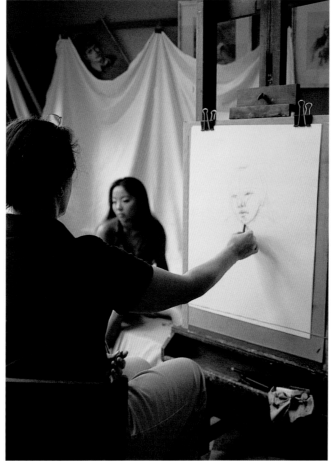

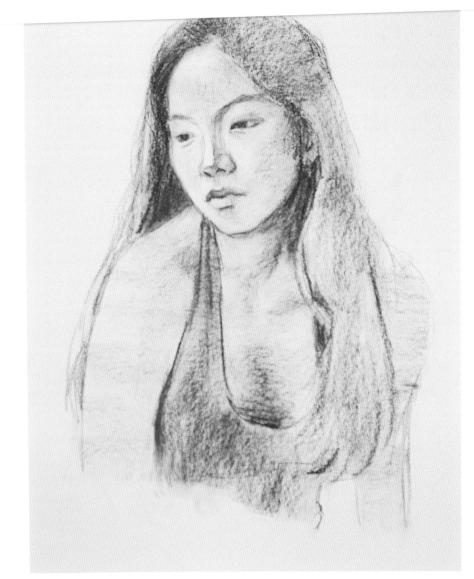

forces you to simplify the form you see into terms of value and line. Attempting to create the illusion of form against a background of white is a worthy, albeit challenging, exercise.

Continue using your sepia Conté crayon to establish value gradation. Apply more pressure to the darker areas and shadows, lessening the pressure for the mid tones. For the broader expanses of tone, use the side of your Conté crayon.

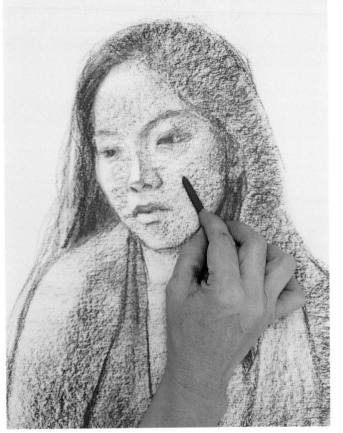

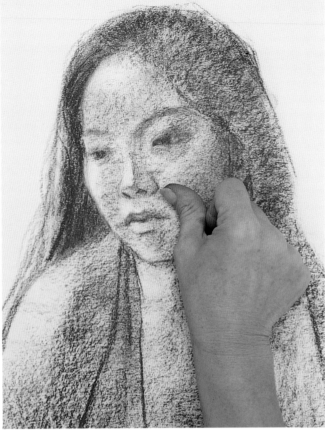

5 Strengthen the Value Gradation

Strengthen the value gradation by lightly dragging the broad side of the Conté crayon across the paper. This will leave large areas of a grainy value across the paper's surface. Define the features more with a pointed Conté crayon.

6 Smooth the Grain

A good rule of thumb (pardon the pun) is to avoid using your thumb or finger as a drawing tool. The natural oils on your skin can damage the drawing, and you risk smearing other areas of the drawing later. But with a study like this, you may use a very clean, dry thumb to selectively soften the grain. This is a good time to correct for likeness. Subtle adjustments will make an enormous difference in the portrait's final appearance.

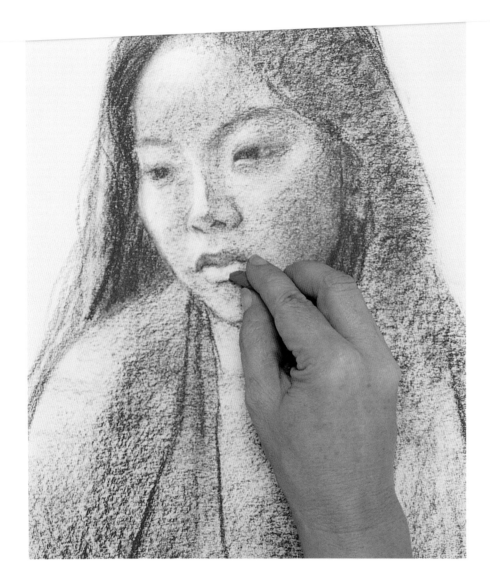

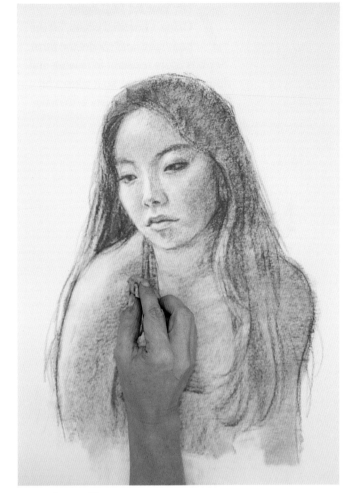

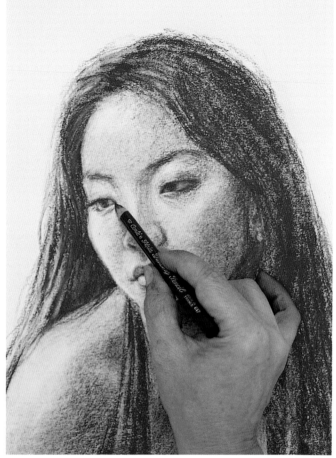

8 **Sweep Tone**
Strengthen the value gradation by lightly dragging the broad side of the Conté crayon across the paper, leaving large areas of a grainy value across the paper's surface. Define the features more with the point of the Conté crayon.

9 **Add Final Details**
For the finer details of the final drawing, use a sharpened sepia Conté pencil. Re-establish small areas of the darkest value. Assess your drawing and make any final corrections.

The Finished Portrait (opposite)
At the outset, I was disappointed that Linda's leg kept falling asleep; it forced me to abandon the full figure pose. Now I actually prefer the intimacy of this pensive pose.

Linda
Conté on bond paper

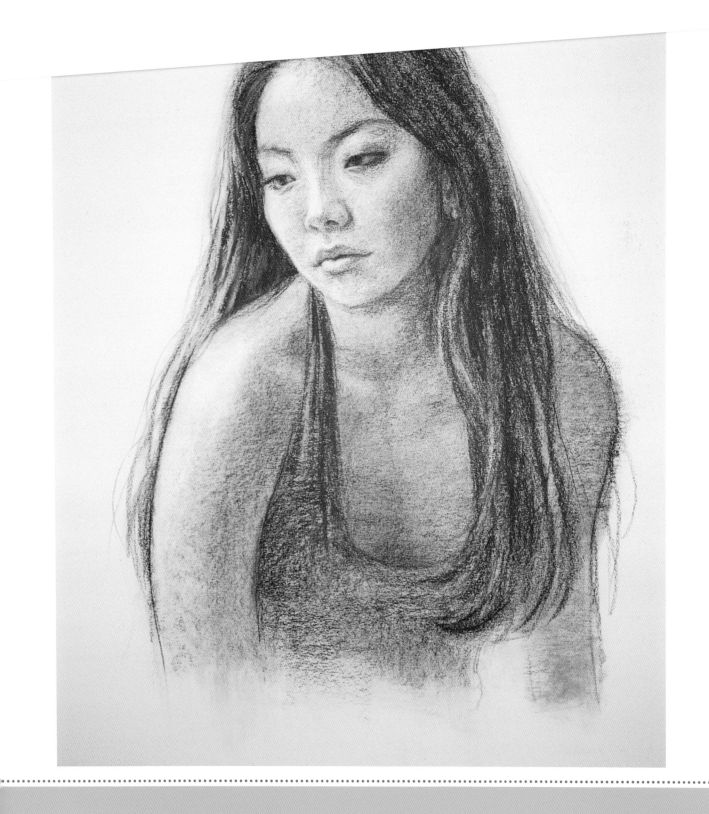

Portrait of Jessica in Charcoal and Conté

MATERIALS

Fabriano Roma paper in light gray

Soft vine charcoal

Soft willow charcoal

Compressed charcoal stick (soft, pointed)

Chalk pencils in sanguine and white

Conté crayons in sanguine, black, white and gray (pointed)

Chamois cloth

Kneaded eraser

Squirrel quill brush

Straightedge

Drawing board

Easel

Bulldog Clamps

Supersized rubber band

Stretched linen canvas

Practice paper

In the 1400s Leonardo da Vinci drew with colored chalks and helped establish red chalk as a standard figure-drawing medium for many other artists, including Michelangelo, Raphael and Rubens. While many artists have used a combination of black, red and white or gray chalks, it was during the Rococo period of the eighteenth century that French artists such as Watteau, Fragonard and Boucher popularized the *dessin a trois couleurs* ("three color drawing") on tinted paper. The paper often had a warm gray or light blue tint.

Using the three-color technique is a convincing way to introduce skin tones, eye color and the blush of lips and cheeks. The paper tint serves as a middle tone while subtle use of the white or gray chalk indicates highlights. When mixed with the black, the gray produces a blue hue. When mixed with the red, the white creates a delicate pink.

1 Prepare Your Materials

For a small piece like this head study, prepare the paper by folding to the desired size, then placing a straightedge along the folds and tearing the paper against the straightedge to imitate a deckled edge. Secure the paper to a drawing board with padding underneath using Bulldog clamps and a supersized rubber band. Make sure to have generous padding underneath, such as a pad of newsprint or, as in this case, a stretched linen canvas to provide the necessary "give."

Stand at your easel and draw a few practice heads on inexpensive paper to warm up. Hold the charcoal as shown and work loosely, swinging the arm from the shoulder.

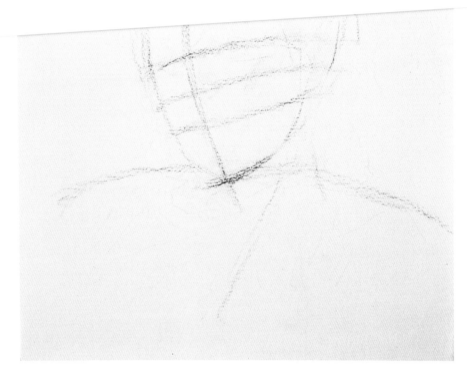

Mark the eyes halfway between the top of the head and the bottom of the chin; Mark the nose halfway between the eyes and the bottom of the chin; mark the mouth halfway between the nose and the bottom of the chin.

Search for the general perimeter of the skull while comparing the axis of the head to the tilt of the shoulders. Try to see the skull as a teardrop shape. Keep in mind that this system of measurement is an approximation intended only as a guide to help you place the head and features. Adjustments will be made as you progress.

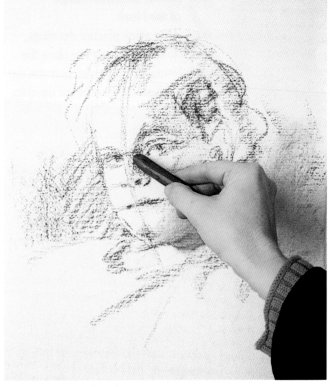

Establish the Shape Map
3 Using a large stick of willow charcoal, state the shape map of the head, face, neck, top line of shoulders and the background with a broad hatching technique.

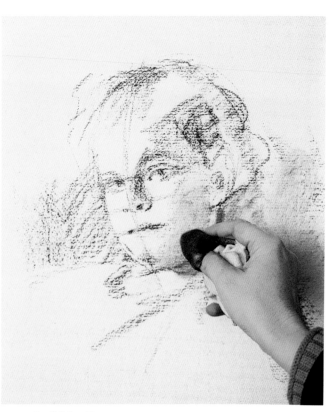

Build the Tone
4 Lightly sweep a dirty chamois cloth across the charcoal to smudge the particles, bridging and solidifying the dark shapes.

5 Lift Tone

Remove the construction marks and lift charcoal from the light shapes with a kneaded eraser.

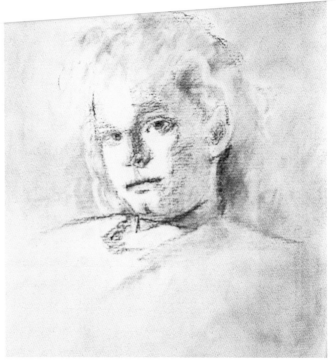

6 Re-Establish the Dark Values

Work back in with a thin, pointed stick of willow charcoal to re-establish the dark values of the drawing.

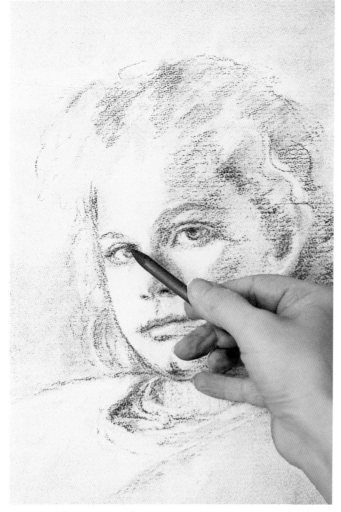

7 Add Linear Details

Switch to a stick of pointed, compressed charcoal to selectively note a few linear details of dark value, such as the hood of the eyelid, the pupil, the opening of the mouth, and so on. Use a fair amount of pressure to produce confident, velvety marks.

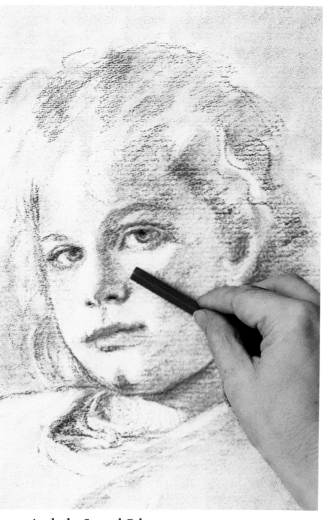

8 Apply the Second Color

Using very little pressure and a sanguine Conté crayon, lightly sweep the cheek shadow. Drag the crayon along the planes of the lips and subtly apply a few grains to the light of the cheeks. Search the face for any other areas where a touch of red would be appropriate. Avoid placing red anywhere on the drawing other than the face.

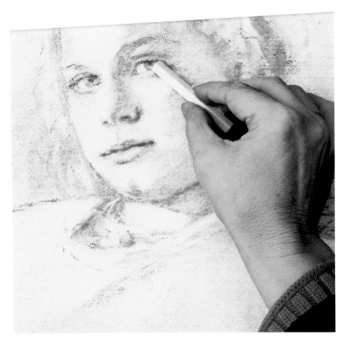

Add Background and Shadow Shapes
Restate the shadow shapes to model the face.
Vignette the head with hatch strokes in the background, using a soft willow charcoal.

9 **Describe With Gray or White**
Describe the eyes with a gray or white Conté crayon.
Dragging the gray into the charcoal will give the iris a
blue appearance. Avoid overstating the whites of the eyes
(which are never actually pure white).

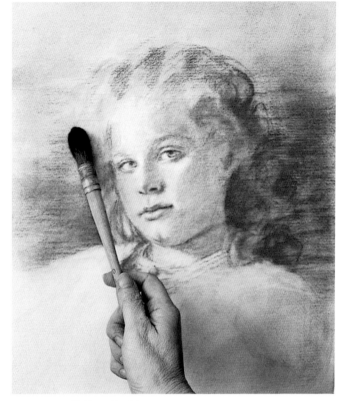

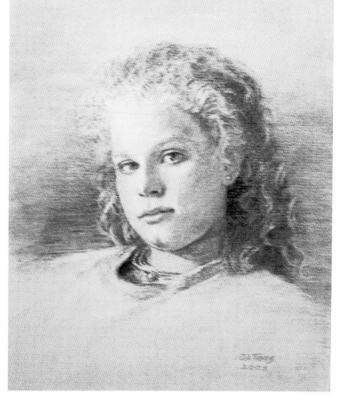

11 Soften the Lines

Using the squirrel quill brush (or a similarly soft brush), and following the direction of the marks, soften the charcoal lines. Keep the transitions from light to dark very gradual to increase the perception of movement and depth.

12 Finish the Drawing

Spend ten minutes or so wrapping up the study. Use the kneaded eraser to clean up, in this case by lifting horizontal lines out of the background and highlights out of the clothes and hair.

Selectively add delicate horizontal lines to the background to imply movement behind the head and to lend an aesthetic finish. Soften the lines by gently rubbing them with the kneaded eraser. Indicate detail by intensifying the darkest darks and the lightest lights on the face with small, linear strokes and firm pressure.

The Finished Portrait (opposite)
This is one of my favorite portrait drawings. I really like the tilt of the head and the subsequent glance that we receive. Creating this portrait of a girl as she exits childhood was a very poignant experience.

Study of Jessica
Conté and charcoal on Fabriano Roma paper

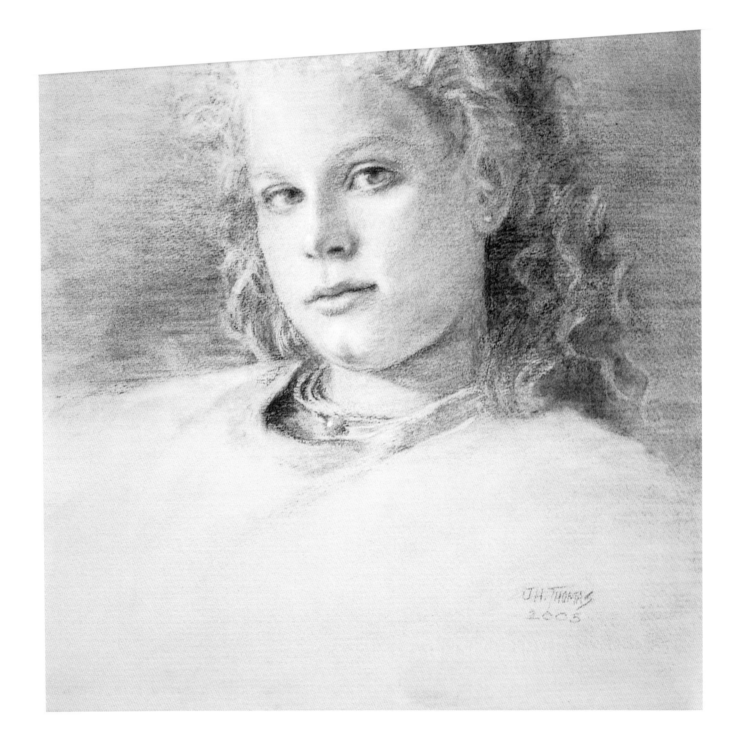

Profile in Charcoal

MATERIALS

Bond paper

Soft vine charcoal
(thin and thick)

Soft willow charcoal

Compressed charcoal
stick

Hard charcoal pencil

Chamois cloth

Stump (optional)

Kneaded eraser

Matte spray fixative

Calipers (or compass)

While teaching a portrait drawing workshop I noticed that even the most advanced students struggled while drawing profiles. When students ended up in the "profile spot," they would invariably complain and even attempt to negotiate a position trade with other students. Since I think of the profile spot as the best seat in the house, I decided to observe them to find out why they were having problems.

My observations resulted in this demonstration designed to emphasize the canon of the head in profile. After watching this demonstration, my students managed to complete convincing profiles.

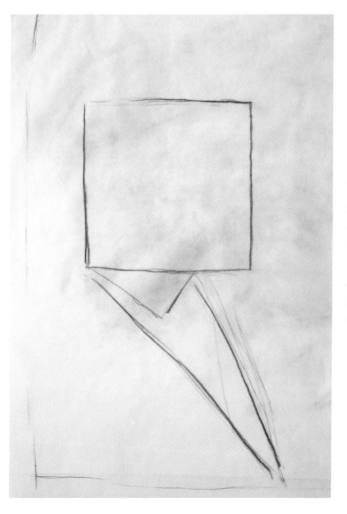

1 Indicate Your First Guidelines

With soft willow charcoal on bond paper, begin with a swift indication of the portrait's perimeter. Determine the middle of the composition by imagining an "X" from corner to corner. If the profile includes the neck and chest, the center point will typically fall in the middle of the cheek.

As you study the model, simplify what you see into a few large geometric shapes. Imagine the head as a box. Draw the width of the box using two marks: the tip of the nose to the back of the head. Use the *exact same measurement* to determine the height of the box (the top of the head to the bottom of the chin). Maintain at least the width of a forehead from the top and left side of the box to the perimeter.

Below the box, sketch a triangle representing the neck. Attach the triangle to the bottom of the box a third of the way from the right side. Place the chest below it. Think of the chest as a wedge shape that serves as a pedestal for the head.

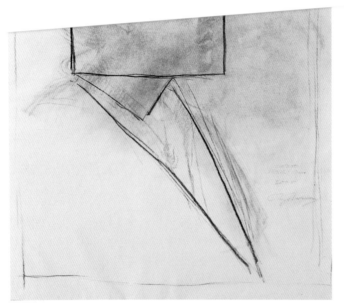

serve as an approximation to get start-
ed, adjusting for the variations will cre-
ate the likeness as the portrait
progresses.

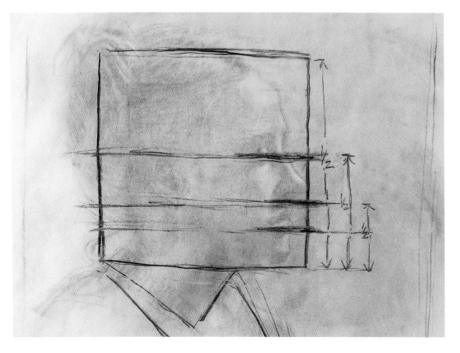

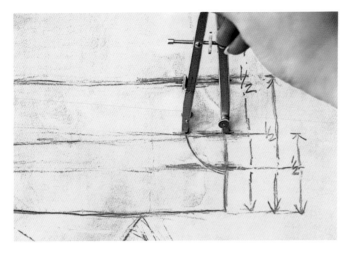

3 Establish the Column of Interest

In a profile drawing, you will have a "column of interest" where all of the subject's features fall. To determine the location and width of this column of interest, use calipers (or "think" like them) to measure the vertical distance between the nose and mouth. Holding these measurements, place the calipers at the tip of the nose (at the edge of the box), then pivot them to mark the back of the nose. Use this mark at the back of the nose to determine the first plumb line. Drop this plumb line from the top to the bottom of the box. This plumb line runs parallel to the perimeter of the box, creating the column of interest.

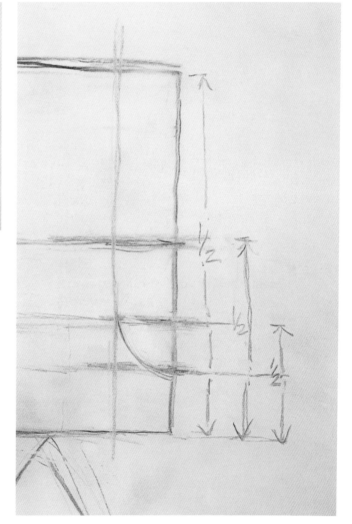

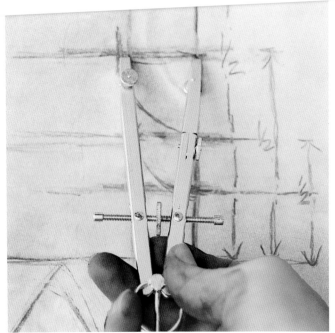

4 **Determine the Width of the Eye Socket**
Go back to the vertical distance between the nose and the mouth. Pivot this vertical distance and use it as a horizontal measurement to determine the width of the eye socket.

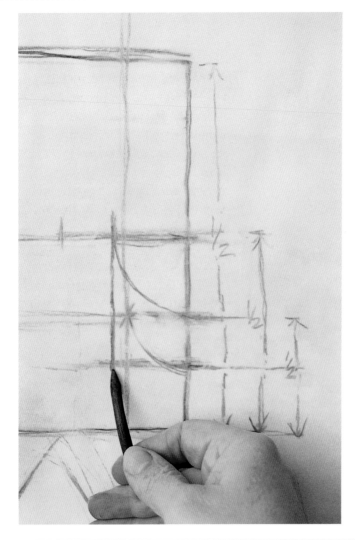

Make More Measurements

5 Take a vertical measurement from the eyes to the bottom of the nose. Pivot this measurement to a horizontal position and mark the front of the eye. From that mark, drop a new plumb line to locate the corner of the mouth. Measure from this mark to the bottom of the nose. Swing this up to determine the width of the eye socket. Drop another plumb line from this point to help place the corner of the mouth.

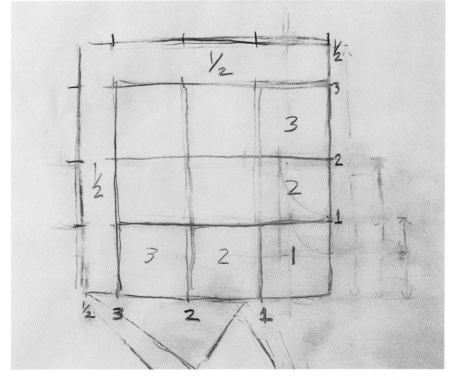

Determine the Canon of the Head

6 Measure from the tip of the nose to the bottom of the chin. Holding this measurement and keeping one point of the compass on the nose, pivot the measurement so that it is now horizontal. Make a mark. This square unit (marked with a "1"), will serve as a standard unit of measurement for this drawing's canon. The head will be three and a half units wide by three and a half units tall. If you find it difficult to visualize this, use soft vine charcoal to subdivide the box into an actual grid according to these measurements.

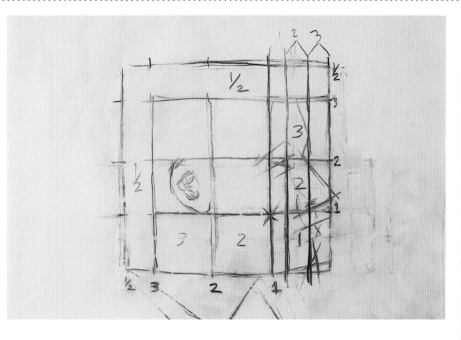

Place the Features

7 The ear usually fits into the third unit of the middle row (which also happens to be the measurement between the eye and the nose). After placing the ear, divide the first column of units vertically into thirds. Sight-measure the various features to place them. To sight-measure, choose a measuring tool (pencil, brush handle, chopstick) and then, holding this tool, extend your arm toward the model. Figure out each angle, then draw and transfer each angle. Look for parallel angles and tangents. Compare positive shapes against negative shapes. Use the grid to correctly place all angles, such as the angle from the nostril to the corner of the mouth.

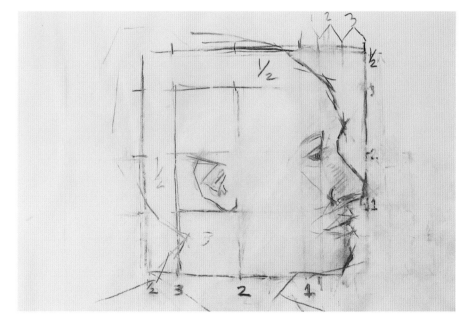

Remove the Grid and Tone the Paper

8 Reveal the drawing by using a dirty chamois cloth or stump to carefully move the charcoal. This removes the grid while toning the paper.

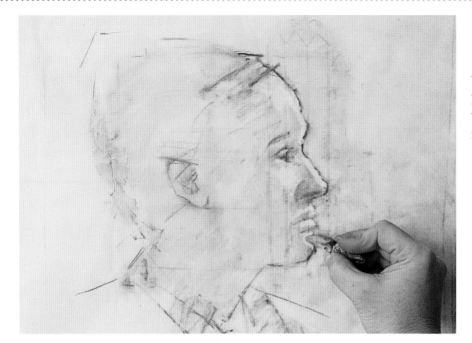

9 Work Subtractively to Add Value Gradation

Using the same system of measurement, work subtractively with a pointed kneaded eraser to draw and lift the light shapes. The features and likeness will become more apparent.

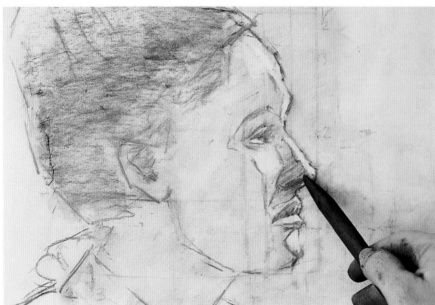

10 Strengthen the Shape Map

Using a very large, pointed vine charcoal, strengthen the shape map. Draw the angular planes and outline the profile. With broad strokes, mass in the darker value of the hair.

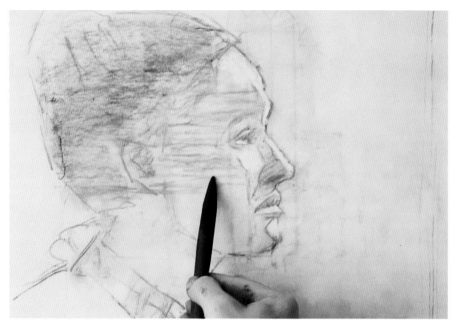

11 Mass In More Dark Shapes

Using a large, pointed vine charcoal, continue massing in the dark shapes. Lay another layer of tone over the top of the midtone and dark values (avoiding the highlights), then distribute the charcoal with a dirty chamois cloth to strengthen the shadows and to darken the background beyond the profile's edge.

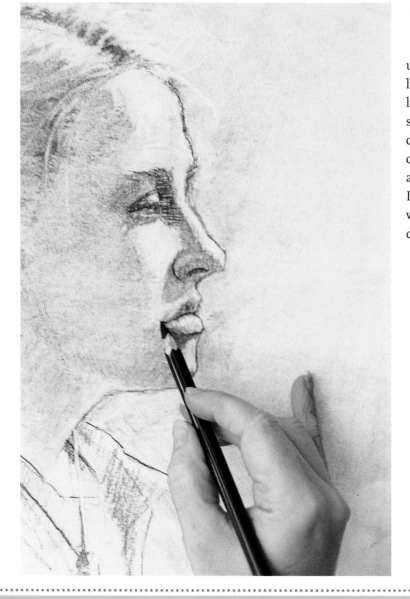

12 Add the Details

Work the entire portrait with subtractive drawing, using a kneaded eraser to lift the highlights on the face and in the hair. Add linear work and restate the darks with a small, pointed stick of compressed charcoal. Finally, switch to a hard charcoal pencil to apply fine hatch strokes along the shadow edge of the profile. Look for the interior subtleties of form within the shadow shapes that can be described with a linear, artistic hand.

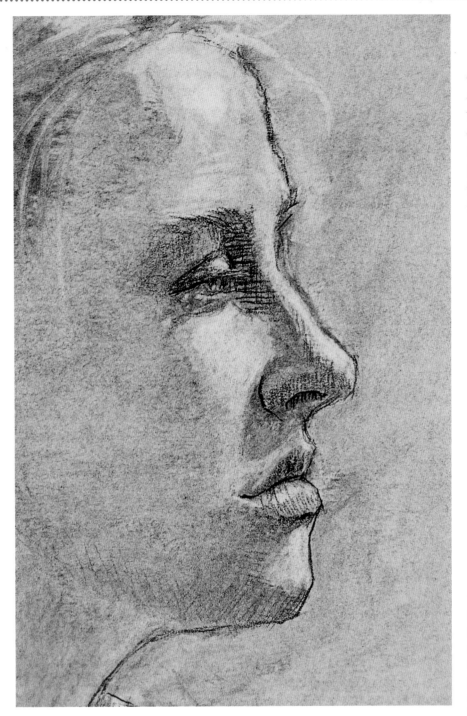

13 Complete the Drawing

Attend to the details and to the quality of the profile's edge with a hard charcoal pencil. Evaluate the shape map created by the values. Are the darkest elements dark enough? Are the lightest light enough? Correct these values where needed. Immediately fix the drawing with spray fixative to prevent smearing of the fragile vine charcoal.

The Finished Portrait (opposite)
Portraits that exhibit the use of a canon make a strong statement through their constructed appearance, revealing the knowledge and confidence of the artist. The sound construction also provides a beautiful venue to exhibit "the hand of the artist" through expressive detail work, in terms of surface texture, value transitions and line quality.

Practice drawing profiles in vine charcoal using this system of measurement. Use different models and lighting. And make sure to practice drawing the profile in both directions. After ten or fifteen studies, you'll internalize the knowledge and be able to visualize without having to draw all of the plumb lines or units of measurement. You will soon be equipped to rapidly draw a profile that is at once accurate and compelling.

Profile of Model in Charcoal
Charcoal on bond paper

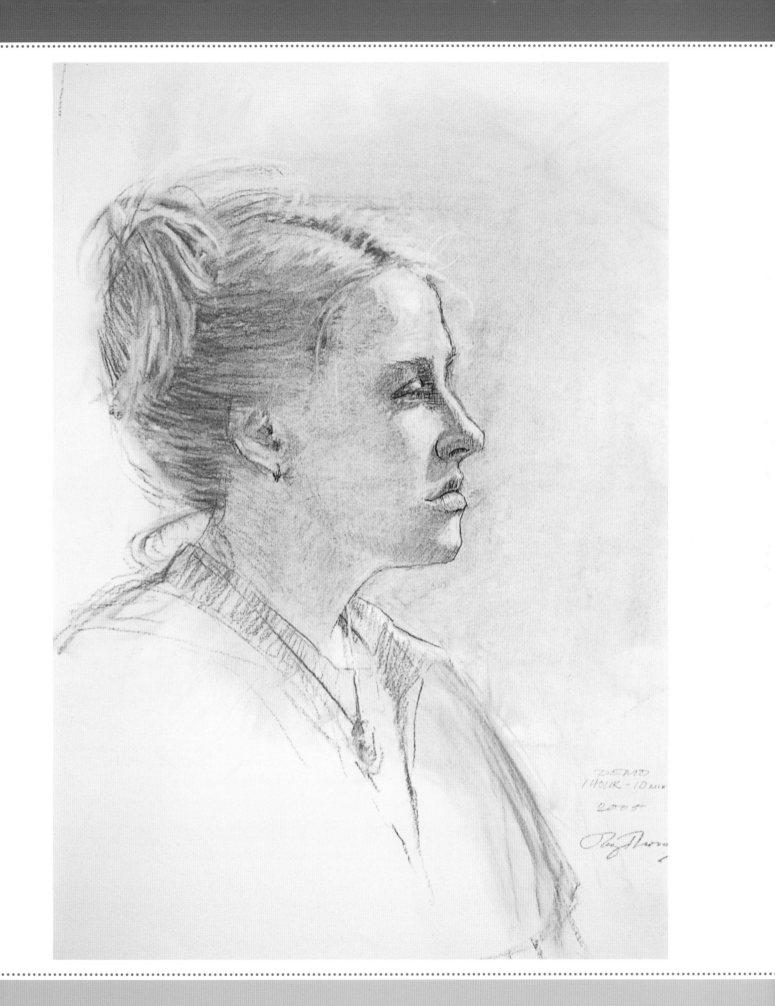

Portrait of James in Sumi Ink

MATERIALS

Black Sumi ink stick

Hot-pressed Strathmore bristol board (plate finish)

Squirrel pointed round wash brushes (various sizes)

suzuri stone, or inkstone

water

Cloth

Hair dryer (optional)

In Renaissance theory, all visual art was seen in terms of drawing, or *disegno*. This discipline of drawing appeals to the intellect and is not limited to the specific act of making marks. When executing a work of art, you are exercising your drawing skills, regardless of medium.

This particular portrait involves a fusion of techniques. We typically think of traditional Sumi-e as calligraphic, consisting of just a few economic brushstrokes, which is the style known as *hakubyou*. In this demonstration, I'll be taking liberties with *Suibokuga*, a monochromatic technique that uses many layers of light and dark washes to create a sense of light and shadow.

Prepare Your Materials

To prepare the warm, velvety ink, dip the stick into water and grind it over the Suzuri stone in a repetitive, circular motion. Wet the back of the bristol board to prevent warping.

Select the areas of the portrait that will remain white. These must remain dry. Some artists use masking fluid to protect the white areas, but masks have an intrusive nature and can damage the paper. It's best to simply be careful while blocking in the shape-map. Use water to outline the areas that are to remain white before placing pools or washes against them. This creates a dam or wall that will stop the wash from bleeding into the white area. The hot-pressed bristol board is nonabsorbent, which will allow you to selectively lift some tone, but not a lot. Hold the brushes with your thumb, index and middle finger at a generous distance from the bristles. Leave your arm and hand unsupported so your movements are freer.

A SUZURI STONE

For this process, you'll need a Suzuri stone, or something similar. A Suzuri stone has a well at one end to hold water and a flat surface on which to grind the ink stick. During grinding, the carbon particles dissolve in the water and produce ink. More grinding produces darker ink. The process requires time and patience. The darkness of the ink can also be adjusted with more or less water on the stone. After each session, the stone must be thoroughly cleaned, since dried ink on the grinding surface is hard to remove, and will make it difficult to grind ink later.

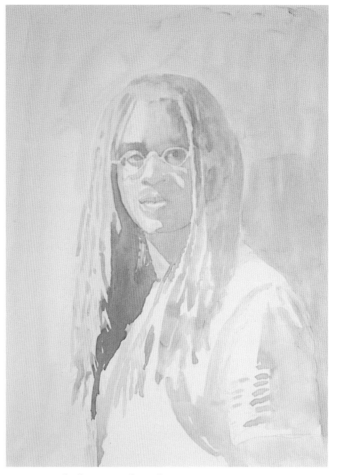

2 Apply the First Wash to the Areas of Dark Value

This portrait involves many layers of ink washes. It is imperative to work in large, simple shapes. Begin with pale washes, making each new layer darker than the last. The process is time-consuming; each layer must dry before applying the next layer. A hair dryer can be used if held at a distance on a low setting, but you must be careful to keep the washes from blowing across the paper and to prevent the heat from warping the paper.

To apply the first layer of ink, dip a brush in clean water and wet the areas of the portrait that will be darkest. Keep the board flat while you work. Flood the moistened shapes with an ink wash. Let this dry flat.

3 Apply the Second Wash

Consider which areas you want to leave lighter and which you want to continue darkening. When the previous layer has dried, outline the shapes you wish to darken with clean water. Load a brush with ink and the lay another wash of ink over the dark shapes. Let this dry.

4 Continue to Selectively Darken

Select and simplify the layers into shapes. Draw around the shape with water, then wet the inside of the shape. Now flood the moistened shape with an ink pool and let it dry flat. Avoid going back into it, as you might cause it to become mottled.

Here you can see the damp wash on the lower left side of the face and neck.

Let everything dry before proceeding.

BRUSH SIZES

Use larger brushes for larger areas and smaller brushes for smaller areas. Let the size of the shape to be painted determine the size of the brush.

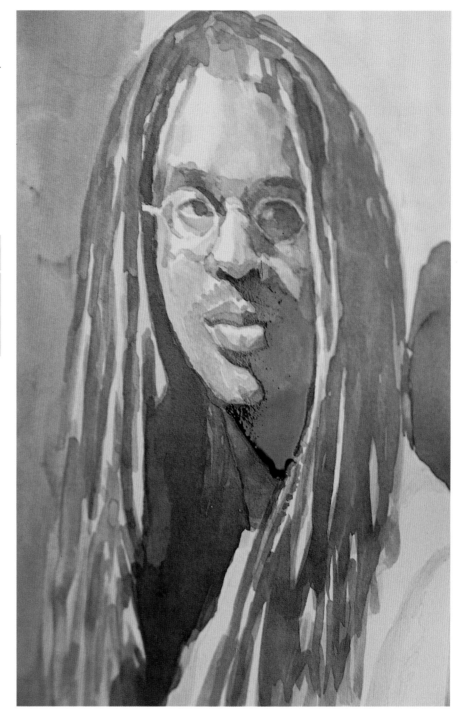

5 Add Tonal Variation

Again, outline the shapes you wish to darken with clean water, then flood the shapes with ink. Here, I've started darkening the shadow behind the subject.

For tonal variation within a shape, flood the moistened shape as before, then tilt and rock the support so the ink runs and drips. Take care to control the pool so that it does not break the surface tension created by the dam of clean water.

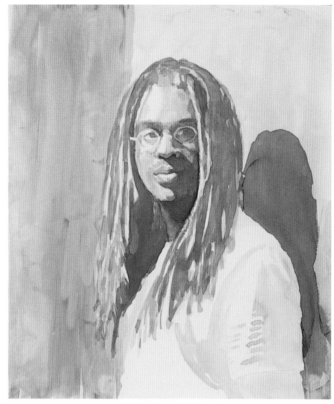

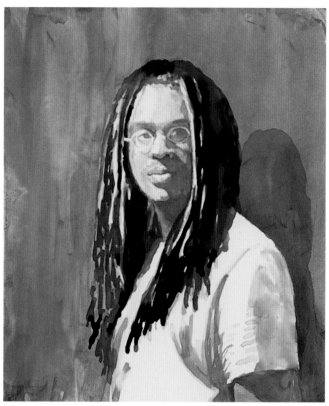

6 Continue Building Form
Continue to build form by increasing the value range, keeping the shape map in mind. Here, I've started layering tone on the background as well as the subject, being careful to always outline the shapes with clean water before flooding with ink. Let everything dry.

7 Darken the Background and Larger Shapes
At this point, you may need to re-wet the back of your board to prevent warping. To develop the background, isolate the figure with water, then darken the background with successive ink washes.

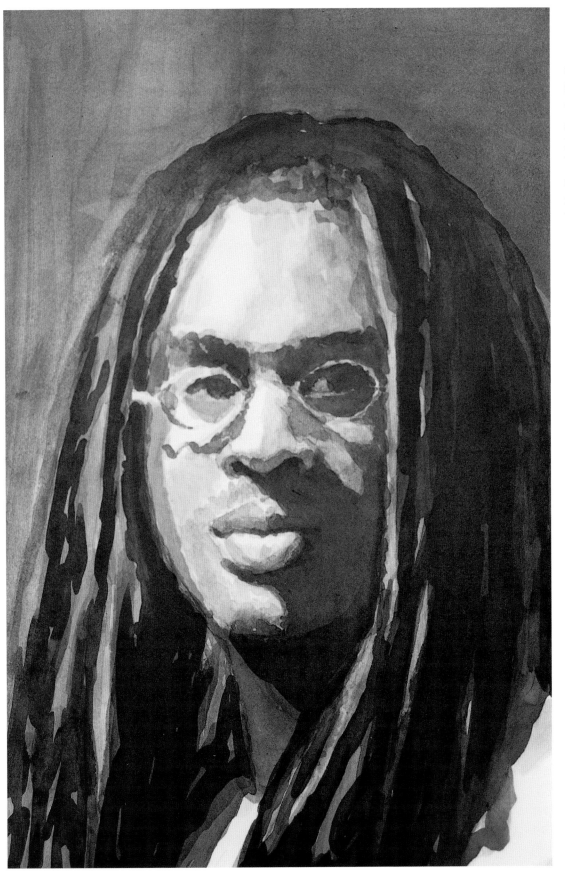

8 **Darken the Details**
Grind a darker ink (more ink, less water), then carefully develop the darks. Develop the darks by "drawing" directly with dark ink and a smaller brush.

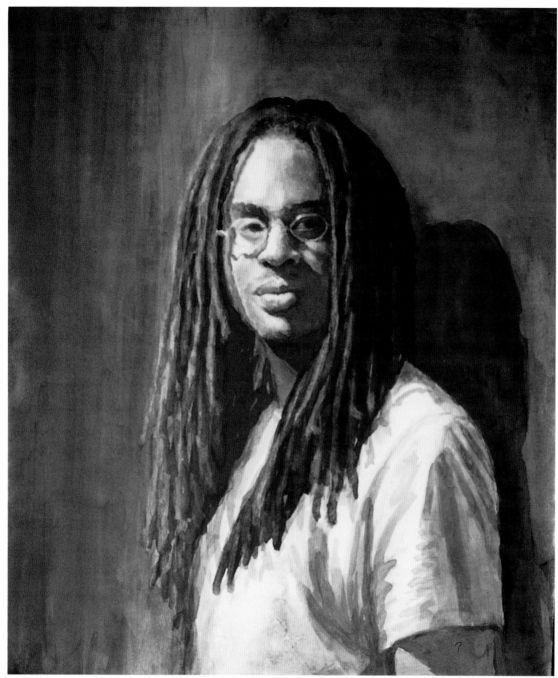

The Finished Portrait (opposite) James is a New York City artist and teacher. We met while I was working on portrait commissions in Manhattan. He has a delightful sense of humor, and I was grateful for his generous hospitality. I had visited the city numerous times but had a more regional experience with James as a companion. His stature and long dreadlocks, in combination with his intelligent and direct gaze, make a dramatic portrait.

The single light source created a value range of theatrical proportions, providing a perfect opportunity to experiment with this form and technique.

James
Ink wash on hot-pressed Strathmore bristol board

9 **Lightly Scrub the Portrait**
After the piece is dry, take a wet cloth and selectively scrub areas for a hazy, blended effect. The only areas receiving that treatment on this portrait were a few edges on the dreadlocks.

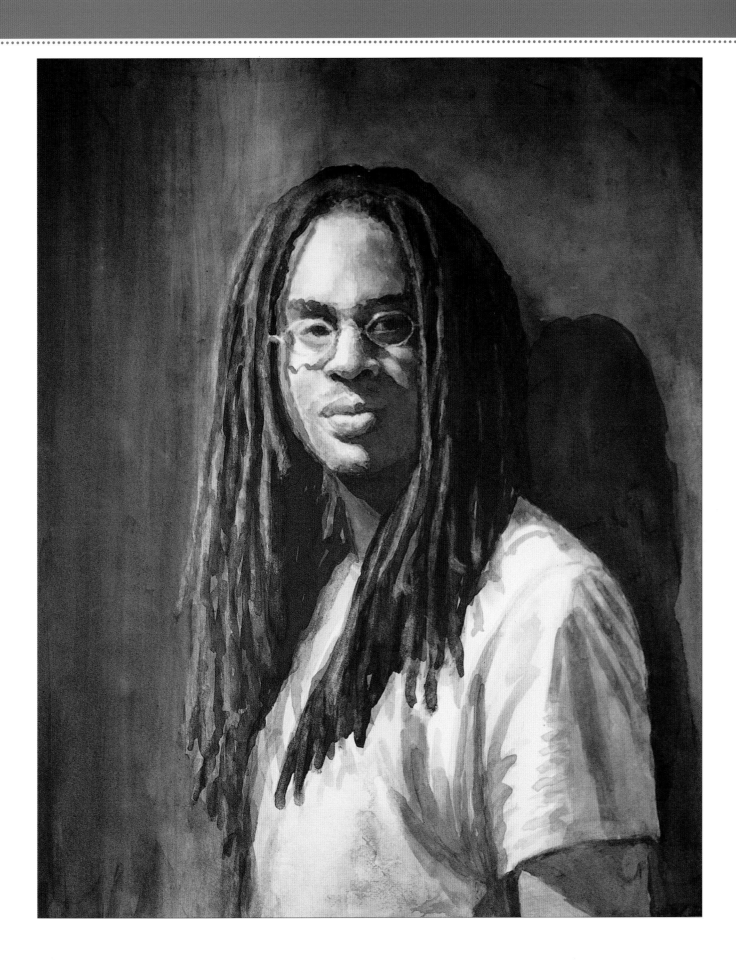

conclusion

When reading about the lives of artists, you'll soon notice that many lived in or near big cities, had access to great art in world-class museums and developed relationships with other art students. They often received their early training from important mentors in illustrious places such as the Art Students League, National Academy of Design or other art academies, here and abroad. Because my own course to becoming an artist took a very different path, I worried, in the early days, that perhaps I had missed out on something. Indeed, I did face certain obstacles due to my provincial beginnings, rural isolation and of course, my gender. But now, after years of teaching aspiring artists, many of whom claim to find my set of circumstances at once familiar and encouraging, I am convinced that with research, good information, a willingness to study, determination and lots of practice, anyone can develop the skills necessary to become a fine artist in a realist tradition, regardless of origin.

When I was a child I loved to draw, especially people. When asked what I wanted to be when I grew up, my standard reply was, "I want to be an artist." (Briefly, at age 12, I decided my true vocation was to wear sequins and twirl a baton in a marching band, but never mind that.) I did not know any artists. I knew ranchers, oil drillers, farmers, butchers, teachers, homemakers, hairdressers, tailors and clerks, but I didn't know any artists.

My father was a pipeliner, so we moved from state to state while I was growing up. Art was not taught in any of the elementary schools I attended. The sympathetic teachers who noticed my artistic inclinations put me in charge of bulletin board displays and tolerated my drawing in class; the others snatched up my drawings and reprimanded me for not working. At home I drew with no. 2 pencils and crayons on construction paper and blue-lined notebook paper. I loved to read and, while combing

school libraries, discovered publications containing works by great illustrators; those from the Howard Pyle school were among my favorites. I learned about the Old Masters from poor reproductions in old, musty art history books. On occasion I would notice a portrait or landscape painting in the hallway of a courthouse or an office building, but other than that, I had no real exposure to fine art.

When I was 13, we settled in rural Kentucky where my parents bought land outside of a small town and my father had a welding shop. Still obsessed with drawing, I liked to draw from the portrait photographs in *National Geographic* magazine. I convinced my parents to let me attend weekly art classes in town. The teacher was self-taught and helped support her three children by offering evening art lessons in her basement. It was set up with chairs at long tables and walls lined with shelves of gnarled tubes of oil paint, bottles of turpentine, paint rags, stained brushes and stacks of canvas-covered cardboard panels. Pinned to the wall and tossed around on the tables were various examples of calendar art, pictures from magazines and a few reproductions of famous paintings. The idea was that we would select something and proceed to copy it in oil paint.

I desperately wanted to copy the Gainsborough prints on her wall, but the teacher said that would be too difficult. She selected a black-and-white reproduction of a painting of a tree for me. I could not locate a tube of black in the bins, so I grabbed a tube of Alizarin Crimson instead. When I took off the cap and peeked into the end, it looked pretty dark to me. Imagine my surprise when I mixed it with white. I was thrilled to be painting, and for the next few classes, I laboriously copied the tree in crimson. I was quite pleased with the results and felt like a true artist, even though the teacher and other adult students thought I was ridiculous.

Our teacher, sensing the frustration among

the students with their efforts at drawing and painting, changed with the times and offered classes that could result in immediate satisfaction. Our basement art class began painting on bisque china, industriously turning out plates and teapots decorated with grapes and flowers. I felt sad that I did not share the enthusiasm of the others, but the whole process was simply of no interest to me. I dropped out of the basement painting class.

In high school, I was a voracious reader with a special fondness for poetry and essays. I developed an interest in analysis of public address and was thinking about studying law or perhaps literature. Then my public high school hired an art teacher and turned our windowless study hall into the art room. I was among the first students to sign up for the class. On the first day, I sat at the very front of the room, scarcely able to believe my good fortune. I was a bit concerned that some of the other students were noted troublemakers. My fears about the other students turned out to be well-founded: Most had enrolled hoping for an easy class and spent a lot of time goofing off, but I managed to remain an eager student.

The art teacher was young and fresh out of college. He introduced us to art history, gesture and contour drawing, watercolor, pastel and silkscreen. Mr. Gaby encouraged me to enter my first art contest, where I won first place. He also took some of the promising art students to visit a couple of university art departments. By the end of my senior year, I decided to attend college and major in art. Once again, I wanted to be an artist.

I received a small scholarship to a state university. There, I expected to learn the valuable fundamentals needed to develop good drawing skills. I took life drawing courses, but as time slipped by, I knew something was wrong. My drawings, while better than most, still appeared crude to me. We were discouraged from reading

art periodicals or instructional books. Instead, we studied the more conceptual and expressionistic works of politically correct modernists. The message became clear: our sensibilities needed to be much more avant-garde. Some of my classmates changed majors or transferred to other liberal arts universities (only to find the same attitude in other art departments). The remaining art students worked to contrive pieces that would meet department expectations. The class critiques resembled group therapy. We drew drew in the dark to exotic music while the teacher read free-verse poetry. My patience wore thin.

One day, during my third year, I was struggling with anatomy while drawing a model. I asked for help, and insisted that the professor demonstrate. As he drew, my heart sank. It became clear that I, a rank novice, had more understanding of the human form than my teacher did. I began to request, from all of my teachers, more emphasis on the teaching of fundamentals and less preaching about making a statement. I wanted a vocabulary of solid drawing skills, a knowledge of perspective and color theory and an understanding of anatomy to make my statement. These were the fundamental elements that I assumed all art teachers would know and teach. My professor, who was also the department head and my advisor, responded by suggesting that I should become more intellectually mature. He gave me a reading list of well-known books of poetry, fiction and philosophy, most of which I had already read, and none of which, alas, had anything do with drawing or painting.

Disgruntled and cynical, I became more vocal with my complaints. It seemed that academia had become big business, and anyone, regardless of actual ability, who cooperated through a few years of college art courses could be declared a fine artist, with the documents to prove it. Times had changed, and so too had the liberal art definition of fine art. Finally, during an advisor meeting, the head of the art department determined that I simply did not have "what it takes" to be a fine artist and recommended that I change majors. I was reminded of the time, years before, when everyone in my art class started painting on bisque

china. Once again, I felt sad, but their ideology was of no interest to me. I had become a heretic. That afternoon, with a sense of rebellion and a bit of uncertainty, I withdrew from college.

While in college, I did, happily, fall in love with one of the life drawing models. Fredrick and I married after I left school, and the following summer, I gave birth to the first of our three children. Fred had a degree in fine arts and had grown up on a Kentucky farm. We returned to farming and became very busy raising our family. During those years, I did not abandon my drawing or my research of great artists; I kept a journal and a sketchbook. While expecting our third child, I met Kentucky portrait artist Sandy Spiegel, who advised me to renew my lapsed subscriptions to art periodicals, take workshops (beginning with Daniel Greene) and to discipline myself to draw everyday. I followed her advice and it changed my life. Fred stayed home with the children while I traveled to study.

That first workshop was an amazing experience. In the course of one week I learned a vast amount. The other workshop participants were valuable resources, suggesting books and other artists to research. Then, armed with coffee-table books about great artists and good instructional books, I taught myself. My appetite

whetted, I begged for and borrowed money so I could attend workshops. Some of the national art competitions and art academies offered workshop scholarships, and I won a couple of those. Like a sponge, I absorbed as much tangible information as I could from each experience. I watched many drawing and painting demonstrations and took copious notes during lectures. Traveling for workshops, and later for commissions, took me to cities with museums, where I finally saw great drawings, paintings and sculpture firsthand.

With such a drought of art training during the twentieth century, I am grateful to the brave few who broke rank and kept the important aesthetics alive, passing on the knowledge to dreamers like me. With so many seeking sound training in drawing, painting and other forms of fine art, I am proud to be among the professional artists designing crash courses, in the form of workshops, to meet the growing demand for traditional training.

I trust my story, along with the methods shared in this book, will be of value in your own artistic quest. Being an artist, regardless of the path you travel, is sure to be an amazing journey!

Gesture With Glove
Charcoal on bond paper

MAKING TIME AND SPACE FOR ART

For the past twenty years, I have been a full-time professional artist, while married and raising three children! One of the questions I frequently hear is, "How do you find time for art?"

When I first began my career as a professional artist, the children were small and I did not have a studio. At that time my husband worked outside of the home, so I was alone with the children and had to cope with many interruptions as I worked. I learned to multitask while maintaining a focus on my artwork. I also learned to prioritize. How can you find time for art? Here's my advice:

LOWER YOUR HOUSEKEEPING STANDARDS. I was spending too much time and effort cooking, tending to the children and keeping the house in order. Needless to say, I was not producing much art, so I changed my approach to life. My husband took over some of the chores and eventually went to work for me full-time. As the children grew, we trained them to do chores. I became accustomed to living in a somewhat messy house. Remember that a freshly waxed floor is soon forgotten, whereas works of art will be cherished always.

ESTABLISH A WORKSPACE. I now have a spacious studio that is separate from my house. But before we built the studio, I managed to complete portrait commissions in the spare bedroom, the dining room and even on the porch. The key is to establish a spot where you can leave your equipment and tools. Keep a French easel packed with supplies, along with drawing boards and paper. At the very least, load a backpack with drawing supplies and keep it handy. That way you can set up your "studio" anywhere.

FOLLOW A SCHEDULE. Set aside time for art each day, and let everyone know that you are *working*, a word they will understand and respect. If you can't bring yourself to draw or paint, use the time to photograph artwork, prepare slides, read art books, order supplies or work on other art-related projects. In the beginning, commit to a couple of hours per day. Once you get started you will find more time.

JUST SAY NO. Sometimes it's assumed that artists do not really work and are available for socializing and for volunteer service. It's important to limit personal phone calls and visits during your working hours. When my husband began working with me as my framer and business manager and we began making our living with art, we had to limit our social life to family and art events. My husband helped coach Little League when our children were small, and I would sometimes volunteer to judge an art show or give an art presentation. Otherwise, we said no to community involvement or socializing that would take precious time away from making art. Since I frequently traveled for commissions, exhibits and teaching, I simply had to commit the remainder of my time to my family and my art.

SEEK ADVANCED TRAINING. Crucial to any artist's development is to seek good training and then work to internalize the knowledge by setting time limits while working from life. Research your favorite artists and then find out if they teach workshops. Look in the back of art periodicals for academies and schools that offer workshops, or start a figure drawing group. Take the time to learn the fundamentals, then discipline yourself to work with confidence and speed. Spending weeks or months on one drawing will not guarantee its success; only skill and understanding can achieve that. Someone asked an artist friend of mine how long it took her to complete a portrait. My friend replied, "The good portraits don't take much time... the bad ones take forever!" It's quite true. My own early work presented many problems that took a long time to struggle through. After years of study and practice, I'm finally learning to work swiftly and economically. This results in better art and better use of my time. Now my portraits seem to complete themselves in no time at all.

Obstacles will be different for each individual, but the fact remains that we all have twenty-four hours in each day. By prioritizing and streamlining your life, you will be able to make way for art. If you dream of becoming an artist, now is the time to begin!

Go confidently in the direction of your dreams. Live the life you have imagined.

HENRY DAVID THOREAU

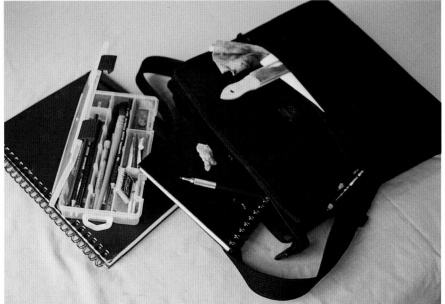

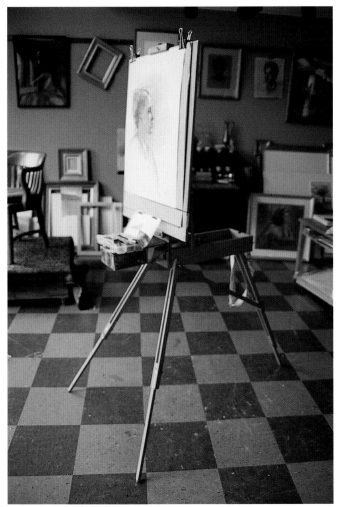

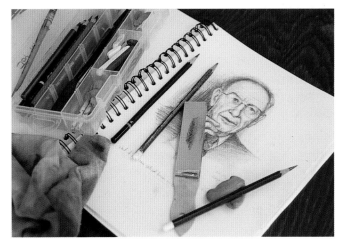

index

 # NURTURE YOUR PASSION FOR DRAWING WITH THESE OTHER NORTH LIGHT BOOKS!

THE PENCIL BOX
From the editors of *The Artist's Magazine*
and North Light Books
ISBN-13: 978-1-58180-729-5
ISBN-10: 1-58180-729-5
Paperback, 128 pages, #33403

Tap the proven techniques and collective
drawing wisdom of over a dozen venerable
Artist's Magazine and North Light artists!
The Pencil Box includes information on
materials, tips for improvement and dozens
of drawing techniques. Includes 14 step-by-
step demonstrations in a range of popular
subjects, including landscapes, portraits,
still lifes and seascapes.

DRAWING PEOPLE
by Barbara Bradley
ISBN-13: 978-1-58180-359-4
ISBN-10: 1-58180-359-1
Hardcover, 176 pages, #32327

Drawing People is a complete course on
drawing the clothed figure from an award-
winning illustrator and drawing instructor.
In addition to basic drawing topics such as
proportion, perspective and value, Barbara
Bradley explains how clothing folds and
drapes on figures both at rest and in
motion, and gives special tips for drawing
heads, hands, and children.

THE DRAWING BIBLE
by Craig Nelson
ISBN-13: 978-1-58180-620-5
ISBN-10: 1-58180-620-5
Hardcover with wire-o binding, 304 pages,
#33191

The Drawing Bible is the definitive drawing
resource for all artists! Craig Nelson clearly
explains basic drawing principles and
shows you how to use a wide variety of
drawing mediums, both black-and-white
and color. Demonstrations and beautiful
finished art throughout will instruct and
inspire you, and the book's chunky size and
spiral binding make it convenient to use
and easy to carry anywhere.

**These books and other fine North Light titles are available at your local fine art retailer
or bookstore or from online suppliers.**